LAKE
Bomoseen

LAKE
Bomoseen

The Story of Vermont's
Largest
Little-Known Lake

Donald H. Thompson

Charleston London

THE
History
PRESS

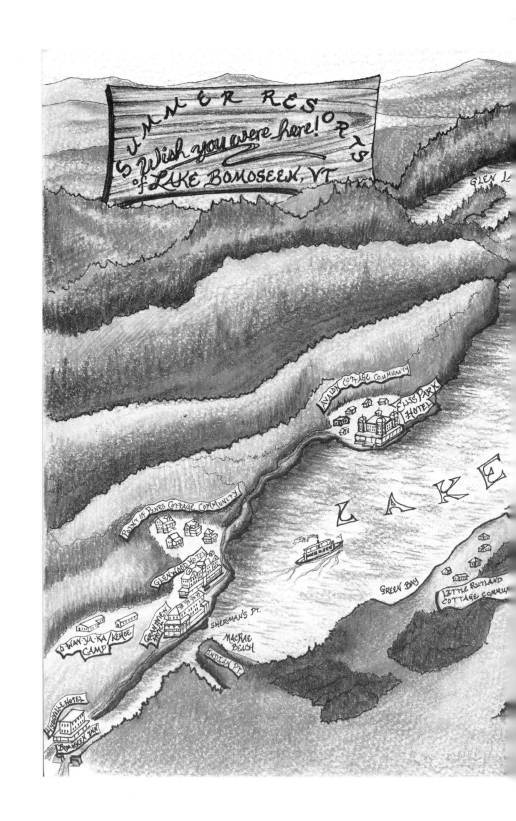

SUMMER RESORTS

Wish you were here!
of LAKE BOMOSEEN, VT

GLEN L

AVALON COTTAGE COMMUNITY

ELLIS PARK HOTEL

POINT OF PINES COTTAGE COMMUNITY

GLENWOOD HOTEL

LAKE

LITTLE RUTLAND COTTAGE COMMU

GREEN BAY

GRANDVIEW HOTEL

O-WAN-YA-KA / KEHOE CAMP

SHERMAN'S PT.

MACRAE BEACH

INDIAN PT.

HYDEVILLE HOTEL

BOMOSEEN INN

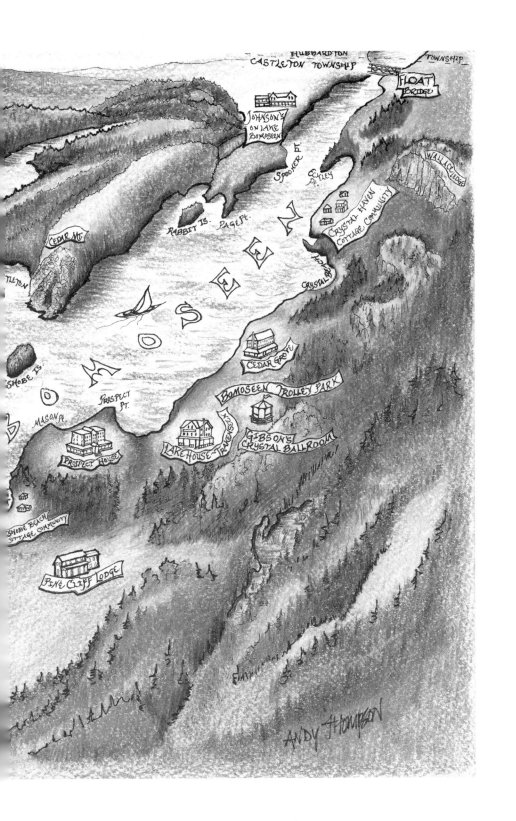

HUBBARDTON

CASTLETON TOWNSHIP

TOWNSHIP

FLOAT BRIDGE

JOHNSON'S ON LAKE BOMOSEEN

SPOONER PT.

ECKLEY PT.

WALLACE LODGE

CRYSTAL HAVEN COTTAGE COMMUNITY

RABBIT IS. PAGE PT.

CEDAR MT.

CRYSTAL BEACH

CASTLETON

BOMOSEEN

SHORE IS.

PROSPECT PT.

CEDAR GROVE

BOMOSEEN TROLLEY PARK

MASON PT.

LAKE HOUSE - TRAKSEEN

GIBSON'S CRYSTAL BALLROOM

PROSPECT HOUSE

SHORE BEACH COTTAGE COMMUNITY

PINE CLIFF LODGE

ANDY THOMPSON

Published by The History Press
Charleston, SC 29403
www.historypress.net

First published 2009

Manufactured in the United States

ISBN 978.1.59629.619.0

Library of Congress Cataloging-in-Publication Data

Thompson, Donald H.
Lake Bomoseen : the story of Vermont's largest little-known lake / Donald H.
Thompson.
p. cm.
Includes bibliographical references and index.
ISBN 978-1-59629-619-0
1. Bomoseen, Lake (Vt.)--History. 2. Bomoseen, Lake, Region (Vt.)--Social life and
customs. 3. Bomoseen, Lake, Region (Vt.)--History. 4. Historic buildings--Vermont--
Bomoseen, Lake, Region. 5. Resorts--Vermont--Bomoseen, Lake, Region--History. 6.
Hotels--Vermont--Bomoseen, Lake, Region--History. I. Title.
F57.R9T46 2009
974.3'7--dc22
2009003230

Contents

Acknowledgements 9

Lake Bomoseen Chronology 11

Introduction 13

CHAPTER 1 The Earliest Inhabitants of Lake Bomoseen
 and the Origin of the Lake's Name 15

CHAPTER 2 Johnson's on Lake Bomoseen and
 Other Smaller Resorts 21

CHAPTER 3 Neshobe Island 31

CHAPTER 4 Rabbit Island and Page Point 43

CHAPTER 5 The Lake House/Trakenseen Hotel 49

CHAPTER 6 The Trolley and Bomoseen Park 61

CHAPTER 7 The Prospect House 71

CHAPTER 8 The Ellis Park Hotel, 1892–1894 81

CHAPTER 9 The Del Monte House and the Glenwood Hotel 89

CHAPTER 10 The Cedar Grove Hotel 99

CHAPTER 11 The Grand View Hotel and Sherman's Beach 107

CHAPTER 12 Hydeville's Bomoseen Inn and the Harbor Store 115

CHAPTER 13 Cottage Communities of the Early
 Twentieth Century 125

CHAPTER 14 Entertainment on the Lake, Part I 135

CHAPTER 15 Entertainment on the Lake, Part II 141

Conclusion 151

Bibliography 153

Index 157

Acknowledgements

Sincere thanks to all the following people who helped in one way or another. If I have inadvertently missed anyone, my apologies.

Lloyd "Skeet" Bronson Jr., Jerry and Davene Brown, Richard Brown, Ron Butcher, Chuck and Lisa Cacciatore, Twig Canfield, Harland and June Cashman, Judy Crowley, Robert Depres, Polly Johnson Dolber, Joseph Doran, Tom Doran, Susan Field, Paul and Marsha Fontaine, Jerry Grady, Ralph "Rex" Hayes, Anna Guyette Hewitt, Holly Hitchcock, George and Linda Jackson, Bryan Kelly, Jan Kelly, Linda Nye Knowlton, Francis and Violet Lanthier, Charles and Evelyn Larson, Jim MacDonald, Sheila MacIntyre, Jay and Carolyn Magwire, Clancy and Janice Maynard, Tom Mazzariello, Carl H. Messner, Mary Kay Miller, Mary Jo and Kathleen Mulligan, Mary Phalen Oczechowski, Mel Patch, Phototec Inc., Charles Prunier Jr., Loyola Kratz Rhyne, Pat Richards, Gordon and Joanne Ringquist, Rosemary "Roz" Rogers, Nancy Ruby, Edward Ryan, Carol Senecal, Dallas Skinner, Linda Splatt, the staff of Bomoseen State Park, Bernard "Bun" Stockwell, John Tolin, Martha L. Towers, Rick Wilson, Danielle Woodard and Robert Woodard.

Lake Bomoseen Chronology

1609	Samuel de Champlain calls the lake "Bombazine"
1850s	Coffee's Picnic House is founded
1860s	Lake Bomoseen is officially named by Robert Morris Copeland
1877	Endearing and Daniel Johnson open their farmhouses for summer guests
1881	July 4, Neshobe Island is named; Barkers' Taghkannuc House opens
1882	Walker's Lake House is established
1888	William Mound opens the Propect House for business
1892–94	Horace Ellis builds the Ellis Park Hotel and it burns down in March 1894
1896	William Mound opens the Glenwood Hotel on the west shore
1898	Ed Dunn establishes the Cedar Grove Hotel
1900	The Grand View Hotel is established
1903	Dan O'Brien begins his O'Brien Hotel in Hydeville
1904	Bomoseen Park is constructed; the trolley spur to the Lake House is completed
1905–10	Point of Pines and Avalon Beach Communities begin
1917–18	Bomoseen Park closes and the trolley line is torn up
1920s–early 1940s	Alexander Woollcott's Algonquin Club meets on Neshobe Island
1921	Gibson's Crystal Ballroom opens (will become the Casino in 1940)
1922	Martin Kelly establishes Crystal Beach

1925–30	Crystal Haven Community is built
1926	E. Quinn and C. Brough open Pine Cliff Lodge; the Bomoseen Country Club is founded
1938	Fair Haven Community Camp is started; O-Wan-Ya Ka becomes the Kehoe Conservation Camp
1967	Mulligans build the longest bar in Vermont at Hydeville Inn; the tradition of "Walking the Dog" begins
1973	The Trak-In Steakhouse opens
1973–74	Cedar Grove and Prospect Hotels are torn down
1981	Trakenseen Hotel is torn down

Introduction

Over the years, many people have visited Lake Bomoseen, the largest lake entirely within Vermont's boundaries. However, most are unaware of its rich history as a vacation spot. The purpose of this book is to create an awareness and appreciation of the many hotels and recreational opportunities that existed around the lake in the past, starting in the late nineteenth century and lasting well into the twentieth century. Using stories, anecdotes, first person accounts, interviews and news articles of the time, it is my hope that the lake's fascinating history will be revealed to succeeding generations of lake residents and visitors.

During this period, Lake Bomoseen had nine hotels and many smaller establishments that took in summer guests. Some were very short-lived, such as the Ellis Park Hotel, which was only in business for two summer seasons, 1892 and 1893. Others, such as the Prospect House, the Cedar Grove and the Trakenseen, existed at least through the mid-1900s.

My family has owned property on Lake Bomoseen for over forty years, since the mid-1960s. By that time, the era of big bands and grand hotels had passed. As a collector of historical postcards, I became aware that once upon a time Lake Bomoseen had been a beehive of summer activity that drew ordinary people as well as the rich and famous, all seeking recreation in one form or another. It is hard to imagine Route 30 along the lake's eastern shore so thronged with summer visitors that a vehicle had a hard time getting through. The trolley line and the railroad made the development of the resorts and cottage communities possible in the days before the widespread use of automobiles. When a trolley spur line was built in the early 1900s, it enabled people from Rutland and the surrounding vicinity to easily travel to the lake. Sometimes thousands arrived on one day for special events. Visitors from farther away could travel by train to the Hydeville Depot and take a steamer to the hotels. During the lake's heyday as a resort area, each succeeding year saw larger crowds.

Through this book I have attempted to bring to life this exciting era on Lake Bomoseen that has been largely forgotten, with the exception of a book researched and written by students of Dr. Holman D. Jordan Jr. at Castleton State College and published in 1999. My book is intended to complement this earlier one; a conscious effort has been made to expand on what was already done through interviews with different people and use of facts and illustrations not contained in the other book.

I am indebted to over forty people, who over the course of the past three years have graciously allowed me to interview them and shared their experiences and photographs of the people, places and events in this book. Many had personal memories of working at the lake resorts years ago, and others are descendants of the original hotel owners. I am especially grateful to Claire Burditt of the Castleton Historical Society for her generosity and the many hours she helped me search the archives. A special thanks also to Jim Davidson of the Rutland Historical Society for helping to find pictures of the trolleys that went to Bomoseen Park. I appreciated the assistance of Karen Sanborn from Castleton State College's Coolidge Library and Carol Scott at Fair Haven Library for use of back issues of the *Fair Haven Era*, a valuable source of much information.

Finally, I have saved the most important person to thank for last—my wife, Carol, without whose support this book would not have been possible. She has helped with many revisions and editing, from its rough beginnings through modifications to meet the publisher's requirements. She has helped greatly with the flow of the text and spent countless hours on the computer. I would like to dedicate this book to her and to the many others who helped make it possible to tell the story of the Lake Bomoseen resorts through their memories and memorabilia. Enjoy!

The Earliest Inhabitants of Lake Bomoseen and the Origin of the Lake's Name

The original Native American inhabitants of Lake Bomoseen lived along the shores of the lake for at least six thousand years, as evidenced by the discovery of a Neville spear point. Algonquin Abenakis and, to some extent, Mohicans and Iroquois occupied the well-drained sandy knoll formed by glacial deposits at the lake's south end. At Indian Point, also called Indian Fields, water from Lake Bomoseen flows into a creek that joins the Castleton River and eventually feeds Lake Champlain. Here Native Americans set up hunting and fishing camps to replenish their food supplies for the winter. The meat and fish were dried and taken to their permanent dwellings some miles away.

Other evidence of the Native American presence on Lake Bomoseen has been found in several areas. A variety of stone tools including scrapers, awls and projectile points have been uncovered on Neshobe Island, Rabbit Island and at Crystal Beach. Jack Crowther reported in the February 8, 1976 edition of the *Rutland Herald* that portions of a soapstone bowl were found at Crystal Beach many years ago before the beach was developed.

During the early 1930s, post molds, the remains of wooden posts used to support seasonal dwellings, were found on Indian Point. The Native Americans used the abundant white birch bark to build canoes and made dugouts of white pine for fishing. In shallower water, fish were netted or speared, using spear points made of slate, chert or quartzite found locally. In deeper water, they commonly fished from a dugout, with a hand line and hook of bone, wood or stone. The Native Americans sometimes fished at night using torchlight to attract the fish. The lake was also home to muskrats, which were hunted for food and fur. The Native Americans would close off the muskrats' tunnels or break into them, and then they would club them as they fled. The descendants of these muskrats still inhabit the lake's banks.

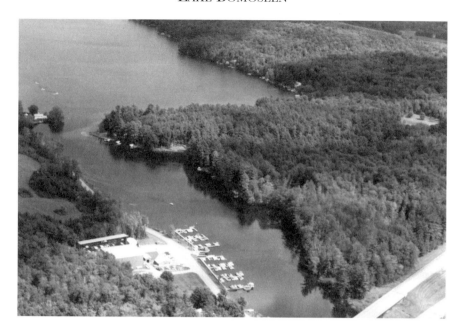

This aerial view shows tree-covered Indian Point at the southern end of the lake. *Courtesy of the author.*

In the Lake Bomoseen area, Native Americans were part of an extensive trade network. One trade route followed the river system from Lake Bomoseen to Lake Champlain, and another went east from Otter Creek. From there portage trails led over the Green Mountains to the east and on to the Connecticut River, eventually reaching the Atlantic Coast.

No one knows for sure what name the Native Americans gave Lake Bomoseen. One story claims that the name is derived from an Abenaki word meaning "keepers of the ceremonial fire" because each year the Abenakis returned to fish and hunt at the lake. Other sources claim that "Bomoseen" comes from an Indian word meaning "pleasant water." In an article on Coon's Store ("Coon's Store: the Coon Family and Other Enterprises"), Professor Holman D. Jordan Jr. states that in the early 1900s Indians "came to camp at the Indian Fields (Indian Point) on the lake. They gathered herbs, grasses and wild rice, and sold beaded work to the tourists. One well-respected family, Black Cloud's, continued to come over the years."

Several alternative explanations for the lake's name exist. Sarah Foster states in an article written in 1914 that "Lake Bomoseen was discovered by Samuel de Champlain in August of 1609." It is a known fact that Samuel de Champlain agreed to travel south with his Algonquin allies to do battle with their enemies, the Mohawk Iroquois. Very little was recorded by Champlain

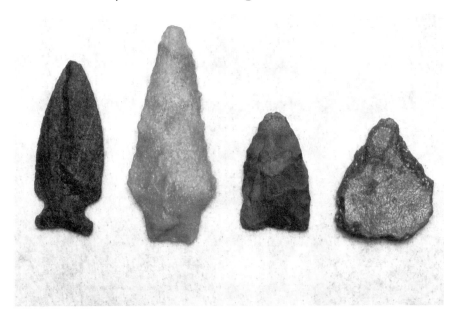

Projectile points and potsherd. Otter Creek Point, second from left, was found on Indian Point by Elsie Thompson. *Courtesy of the author.*

about any exploration done after the battle near Ticonderoga or Crown Point. According to Sarah Foster, though, an exploratory party was sent east of Lake Champlain and followed the Poultney and Castleton Rivers to the outlet of the lake. "When they reached the southwestern shore of the Castleton lake, their eyes beheld all at once the smooth surface of its quiet waters, which reflected the foliage of the surrounding shores, to such a degree that it resembled the appearance of the new cloth that they all by common consent called 'bombazon.'" This bluish green material was popular during the reign of Queen Elizabeth I, 1558–1603. The French called it "bombazin," derived from the Latin word *bombycinus*, meaning silk.

After 1609, the Castleton lake was seldom visited by Europeans. It was not until 1761 that Castleton was chartered as part of the New Hampshire Grants by Governor Benning Wentworth. Noah Lee and Amos Bird came from Connecticut to survey the town in 1767 and 1768. According to *Castleton Scenes of Yesterday*, "Noah Lee and his colored man stayed there the winter of 1768–69 in a cabin on the bluff overlooking the Castleton River south of Castleton Corners." As the area became settled, the earliest land deeds variously called the lake "the Great Pond," "the Pond" or "Castleton Pond." At the same time, the name Bombazon continued to be used. William Blodgett's map of 1789 labeled it "Lake Bombazon," and

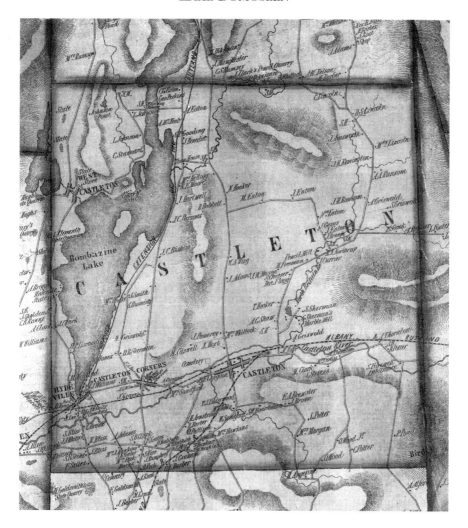

This 1854 map of Castleton, Vermont, shows the lake labeled "Bombazine." *Courtesy of Old Maps (www.old-maps.com), West Chesterfield, New Hampshire.*

on a 1796 Vermont map by D.F. Scotzmann, it is called "Bombazon Sea." The Zodock Thompson Vermont gazetteer of 1853 refers to the lake as "Lake Bombazine."

Another legend has quite a different explanation for the lake's name. One winter, a peddler was crossing the lake over the ice, his sled laden with several rolls of bombazine cloth. As he journeyed toward the next settlement on the other side, one of the rolls unfurled and cascaded across the ice, ruining the cloth. This story concludes that the peddler named the lake after this unfortunate incident.

The Story of Vermont's Largest Little-Known Lake

No matter which version is the true explanation, the name Lake Bombazine was accepted until the 1860s, when Major Robert Morris Copeland purchased property in West Castleton during the slate boom. Copeland decided that the name was actually "Bomoseen," claiming that it was named after the Indian sachem (chief) Bomozeen of Norridgewock, Maine. He asserted that the sachem used to visit the lake frequently and bestowed his name on it. Most historians doubt that the Abenaki sachem had any connection to the lake, as he lived hundreds of miles to the east, but Copeland was successful in getting the name changed to Bomoseen.

Which explanation is the most plausible? All make for interesting stories, part of the greater saga of Lake Bomoseen, from the Native Americans, the first European settlers and the heyday of the early resorts and hotels to its present existence as a vacation spot.

Johnson's on Lake Bomoseen and Other Smaller Resorts

The nine-hundred-acre Johnson farm on the west side of the Float Bridge was one of Lake Bomoseen's earliest summer resorts and existed for seventy years. In 1877, Civil War veteran Colonel Endearing D. Johnson and his brother, Daniel T. Johnson, decided to change their livelihood from raising Holstein cows and merino sheep to lodging guests. By 1880, the farmhouse had been converted into a summer hotel. In the early 1900s, Hollis Johnson added cottages to the original farmhouse site. One of these cottages had originally been the one-room Schoolhouse #11. The Johnsons could eventually accommodate up to seventy guests, including families with children. The success of Johnson's on the Lake grew mostly through word of mouth. The hotel was so popular that guests would often make a reservation for a year in advance when they departed at the end of their current stay. Despite a high percentage of return guests, Hollis Johnson, Daniel and Luthera Johnson's son, also placed ads in newspapers in Albany and Brooklyn, New York, to attract business.

Visitors from the capital district of Albany, New York, nicknamed the place "Johnson's Clubhouse." In 1882, writing in *The Early History of Lake Bomoseen*, G.D. Spencer called Johnson's "a nice comfortable place where guests can get away from everything but their sins." In the early years that Spencer described, meals were cooked by Luthera Johnson. Guests tenting on the camping grounds would cook their own freshly caught fish from the "finest fishing grounds on the lake…Anyone who wishes to drive dull cares away will find when he reaches the Deacon's [Daniel Johnson] he has found just the spot."

Endearing Johnson passed away in 1910, his brother Daniel in 1923, but Johnson's on Lake Bomoseen continued to be operated by Hollis Johnson and his wife, Irene Chessell Johnson. In the 1920s and 1930s, the farm provided fresh food for guests, and what the farm did not produce was purchased from a wholesaler who supplied such things as canned goods and flour.

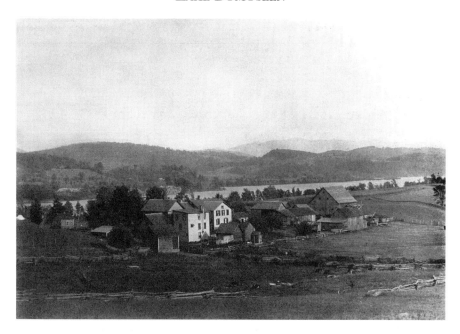

Johnson's on Lake Bomoseen, with pasture in the foreground, began as a converted farmhouse. *Courtesy of Polly Johnson Dolber.*

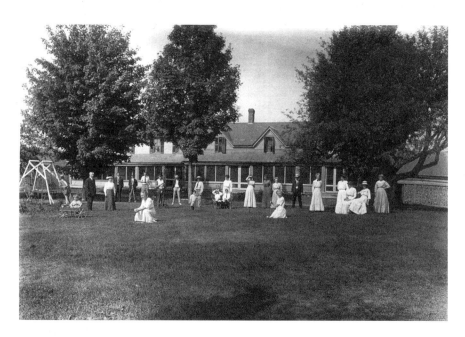

Summer guests pose at Johnson's on Lake Bomoseen. *Courtesy of Polly Johnson Dolber.*

The Story of Vermont's Largest Little-Known Lake

Johnson's was not primarily a summer spot for the rich and famous. Its clientele was largely made up of ordinary working people who sought a relaxing vacation away from the bustle and work of urban centers. Johnson's did occasionally get some more illustrious guests, however. Charlie Mackie, a silent film actor from Long Island, was a longtime guest, and Daniel's granddaughter, Polly Johnson Dolber, had a picture of her grandfather with Mr. Mackie. Charlie Webb, one of Senator George Aiken's staff, and his wife and daughter stayed all summer in one of the cottages to escape the heat of Washington, D.C.

In 1873, Lyman Johnson, father to Endearing and Daniel, built the Float Bridge on the north end of the lake at a cost of $3,000. However, when it came time to be paid for the work, the town was a little slow. Polly Johnson Dolber, Lyman's great-granddaughter, told the family story that her great-grandfather finally got fed up after waiting several years to be paid, so he took a barrel of hard cider to the town meeting. He evidently softened up the politicians, for he got his money. The original one-lane Float Bridge actually did float on the surface of the lake, and this enabled the bridge to adjust to the water level fluctuations in the spring and fall. However, when the ice broke up in the spring, the center section of the bridge would sometimes break away and be carried down the lake, and it would have to be retrieved.

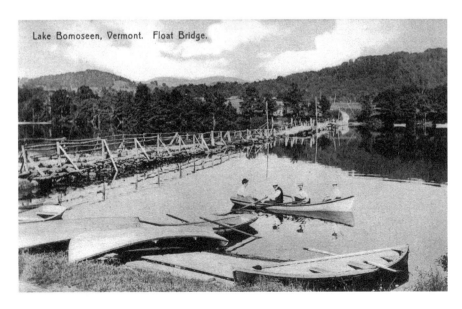

Lake Bomoseen, Vermont. Float Bridge.

The Float Bridge on the north end of Lake Bomoseen as it appeared circa 1910. Boats belonging to Johnson's on the Lake can be seen in the foreground. *Courtesy of the author.*

In 1882, a horse slipped off the side of the picturesque but unsteady bridge and drowned. The owner sued the Town of Castleton for the loss.

Before the end of the nineteenth century, the Float Bridge became a fixed bridge with steel pilings driven into the bottom and railroad ties to support the roadbed. Wooden planks were placed side by side across the bridge. Later additions included two levels of metal pipe railing for safety purposes. This safety railing eventually inspired the "Bomoseen Bombers," daredevil kids who would climb on the top rail and dive into the lake. This tradition endured for years, as local residents grew up and returned to the Float Bridge each summer.

During the second decade of the twentieth century, guests at Johnson's would travel long distances by train and then would be met by the Johnsons' boat, *Minnehaha*, at Hydeville and transported to the resort. When cars became more common, "The familiar sound of cars crossing the Float Bridge...signaled the beginning of the season" in June.

After World War I, Johnson's on Lake Bomoseen was remodeled; the two separate houses of brothers Endearing and Daniel Johnson were joined,

The *Minnehaha* was used to transport guests from Hydeville to Johnson's on the Lake, circa 1910. *Courtesy of Polly Johnson Dolber.*

primarily at the urging of Daniel's wife, Luthera. Her granddaughter, Polly Dolber, recalled, "She would buy up land for one dollar an acre, and when the season ended, her carpenter would want to know where she wanted the latest 'wart' [addition] that year."

Some guests who wished to practice their golf on the premises helped create a three-hole golf course on pastureland behind the main building. Polly Dolber remembered them having a great time on this abbreviated golf course, but eventually it reverted to pasture again.

From 1906 to 1915, the Lake Bomoseen Yacht Club held annual boat races, swimming matches and a parade of decorated boats. During the first regatta, "All the hotels about the lake were decorated with flags and bunting and presented a gala day appearance." The parade started at 11:00 a.m. at the Lake House and continued to the Glenwood on the west shore and then back up to the Cedar Grove Hotel. Hollis Johnson, his mother and his wife all participated in the 1913 regatta, dressed as Uncle Sam, Betsy Ross and Lady Liberty.

Fishermen arrived early in the season and would be lodged in the hotel's northern section, where they joined the Johnsons for family-style dinners. *Beautiful Lake Bomoseen* reveals that, at the start of the regular season, the end of May, "Breakfast, lunch and dinner were served at specific times each day in the dining room, which was approached by a walkway affectionately

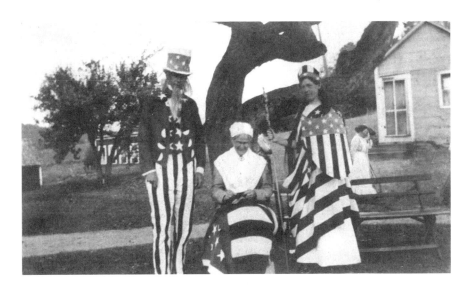

Hollis, Luthera and Irene Johnson dressed in patriotic costumes for the 1913 regatta. *Courtesy of Polly Johnson Dolber.*

known as 'Paradise Alley.'" The hotel did not have a formal schedule of events for either children or adults, with the exception of swimming lessons for the youngsters at 3:00 p.m., taught by Helen McElroy, and an evening children's hour before bedtime. Polly Johnson Dolber remembered that there were always lots of children to play with and how they made their own amusements, whether it was swimming, fishing, hiking or games.

For the children's hour each evening, Mrs. Mattie Webb would play the piano, and the children, sometimes as many as twenty, would line up along one wall to recite a poem, sing a song or do something of their own creation. After everyone had had their turn, one child would pretend to be the sandman and sprinkle sand on the others, at which point they would lie down and recite, "Now run along home and jump into bed; say your prayers and cover your head, " according to Polly Johnson Dolber. This signaled the end of their day, and the children would go off to bed.

The Johnsons employed local people as cooks and waitresses, and they hired hands to do such jobs as butchering cattle. Two cooks prepared the meals, and the third specialized in making pastry. Polly Johnson Dolber recalled, "Some of the waitresses from West Rutland were of Polish descent, and they would not continue to work at the Johnson's unless they were driven to the Catholic chapel across from the Prospect House."

Even with the onset of the Great Depression in 1929, the hotel was often filled to capacity, with up to seventy guests. The middle-class clientele returned to enjoy the simple pleasures of a lakeside vacation: fresh air, peace and quiet, good food, water activities and a family atmosphere. Room rates remained relatively stable; rooms were eighteen to twenty-one dollars per week, with an extra twelve dollars per week for children rooming with their parents. Rowboats could be rented for an additional four dollars per week. The guests seem quite dressed up in the pictures of the era, compared to modern styles of much more casual attire. During the 1930s, when more guests had their own cars, the Johnsons provided space in two garages for a fee of three dollars per week. As with the "Paradise Alley" previously referred to, guests soon nicknamed these garages "Pennsylvania Station."

On May 16, 1933, a fire destroyed the hotel in less than an hour and a half. A 1997 article in the *Fair Haven Promoter* ("It Happened Over Thirty Years Ago") reported, "The fire is believed to have originated from a bonfire which was built early this morning, and which farm workers believed had burned down. Investigators are of the opinion that the embers were carried by the wind to the grass near the icehouse about fifty yards away." From the icehouse the fire quickly spread to the servants' cottages and then to the

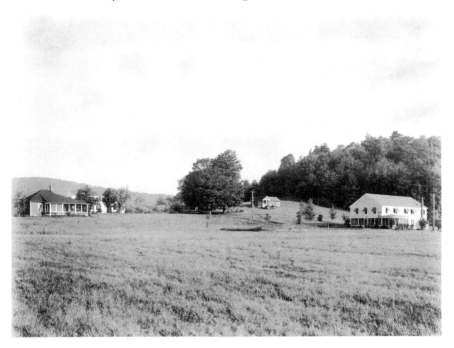

After a fire on May 16, 1933, destroyed the original Johnson's on Lake Bomoseen, this smaller, eight-bedroom hotel replaced it. *Courtesy of Polly Johnson Dolber.*

hotel itself. Mr. and Mrs. Hollis Johnson had just returned two weeks earlier to open up for the season after wintering in Florida. Hollis and William Kelly, a neighbor, were seriously burned in their efforts to save furniture from the hotel. The Fair Haven Fire Company pumped water from Lake Bomoseen on the flames, and they were able to save "two large bungalows, one cottage, a garage and a large barn connected with the hotel."

After the devastating loss of the hotel, Hollis Johnson built a new home on the old foundation, and he had a smaller hotel constructed northeast of his new house. During the rest of the 1930s, guests continued to stay at Johnson's, enjoying much the same activities as before, but they would also drive to Gibson's Crystal Ballroom on Saturday nights or to square dances at Lake Hortonia. Couples dressed up in their finest and danced to the big band sounds of the era at Gibson's. Just before World War II, Johnson's was filled to capacity, including about twenty children, when a polio scare struck. A boy named George Boyle was taken to Rutland Hospital and placed in an iron lung. He did survive, but panicked parents at the resort rushed their children over the Float Bridge and away. One woman, when she heard what was happening, quickly walked up the lakeshore and spent several

hours sketching the landscape before returning. She had been afraid that the authorities would shut Johnson's down. She remained the only guest that season.

The hotel business became more difficult during World War II, as it became harder to get both help and supplies. Polly Johnson Dolber remembered that near the end of the war one guest requested a slice of bread to take with him each night. He was a concentration camp survivor and didn't want to experience that awful feeling of hunger ever again.

By 1945, Hollis Johnson leased the hotel to Roy H. Elliott and two years later sold it to John and Missy Callahan. They ran it until 1953, when there was another tragic fire. The hotel was destroyed, and the Callahans were severely burned. "They were saved from being consumed by the fire by Hollis Johnson but died at the hospital only a few days later," according to Polly.

After his wife Irene's death in 1953, Hollis Johnson continued to live in the house built on the site of the original hotel, and for many years he was one of the few people living on the west side of the Float Bridge, besides the Spooner farm to the south. In 1961, funds were appropriated to build a two-lane concrete bridge, largely thanks to the efforts of State Representative Jeremiah Grady. While the bridge was under construction, the few inhabitants of the west shore had to take the rough and unimproved Cedar Mountain Road south to West Castleton and down Creek Road to Hydeville, a bumpy and rather inconvenient trip.

Polly Johnson Dolber resided in her father's house until her death in late 2008. No visible signs of the thriving summer resort called Johnson's on Lake Bomoseen remain. The area on the west shore of the Float Bridge is now dotted with private vacation homes built in recent years along the Johnson-Spooner Road, named after the original residents.

Although not strictly resorts, there were several smaller recreational sites along the lake in the mid-nineteenth century. Some just provided places to have a picnic, rent a rowboat to go fishing or have a dance in the evening. One such smaller place was simply called Doc Hyde's Place. It was located on the east shore of Lake Bomoseen, across the Float Bridge from Johnson's, on Rustics Road. It consisted of small, simple cabins and tent platforms on which people who enjoyed camping could pitch a tent. The man in the photo opposite seems to be relaxing in comfort with his rocking chair and his coffeepot.

In the same area across the Float Bridge and opposite Johnson's, Theron Goodwin and his wife ran a boardinghouse and campground around 1882, according to G.D. Spencer's book, *Early History of Lake Bomoseen.* "Theron

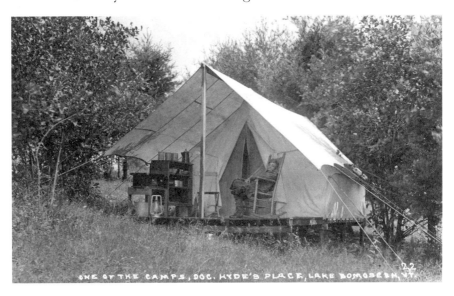

Doc Hyde's Place, just south of the Float Bridge on the east shore, provided small cabins and tent sites, as pictured here. *Courtesy of the author.*

accommodates many in his house; has some fine camping grounds; his wife also well understands the first and last principles of cooking." Farther south on the east shore the Pond family took in summer guests and ran the family farm. Aside from providing boats for their guests' use, these families did not offer fancy surroundings or elaborate amusements; rather, they catered to people who simply wanted country air and a respite from the city and work.

Continuing south, Coffee's Picnic House hosted large groups for picnics in the spacious dining hall, which had a dance floor on the second story. The dining hall offered free ice water and a soda fountain for five cents. Coffee's place also had fourteen well-maintained boats available for guests. This establishment was the earliest of the Bomoseen resorts to accommodate transient guests. It was originally started in 1855 by Commodore Fordyce S. Heath and later expanded on by Mr. Coffee, whose place could accommodate twenty-five guests. He perhaps started a trend, which persists today, of continually upgrading to make facilities bigger and better. The August 7, 1896 edition of the *Poultney Journal* mentions the annual meeting of the Castleton Chowder Club at Coffee's, with E.H. Armstrong as toastmaster and chowder cook.

A little farther south along the east shore was Bishop's Pic-Nic House, run by decorated Civil War veteran Harvey Bishop. An 1878 advertisement

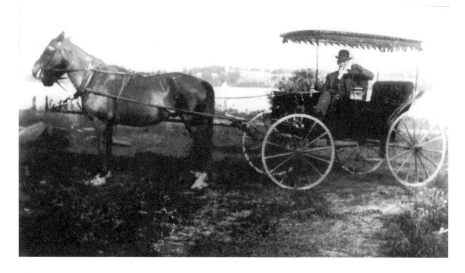

Harvey Bishop, founder of Bishop's Pic-Nic House, makes a grand appearance in his surrey with the fringe on top. *Courtesy of Nancy Ruby.*

describes his picnic house being located just south of Bixby's livery, where the Cedar Grove Hotel would later be built. Bishop advertised that he provided all the necessary supplies for fishermen, including the new Lake George boats.

At the southern end of the lake near the creek was the Russell House, situated in a grove of pines. It had a dock house and dock large enough for the steamboat *Naomi*. The Russell House was run by C.M. Hawkins, and it could accommodate seventy-five guests. It was only a short distance from the Hydeville Depot.

Neshobe Island

Neshobe Island, about eight acres in size, has provided a great deal of colorful history to the area. In the 1800s, it was known locally as Chowder Island because area residents would hold chowder parties there. It changed ownership several times in the mid- to late 1800s. In 1880, Jane Barker purchased the island for her son, A.W. Barker, with the idea of running a hotel there. However, the previous owner disputed her title to the island and it wound up in court. Eventually, two years later, the case was settled in Mrs. Barker's favor.

The name Chowder Island was never official, and in 1881 the Rutland Historical Society proposed that a Fourth of July celebration be held at Mason's Point, opposite the island, for a naming ceremony. A committee of three society members suggested the name "Taghkannuc," after an Indian chief who, according to local lore, had lived on the island and also on Indian Point. It was believed that his daughter had died of illness and was buried on the island. Supporters of this name felt it was "Indian-like" and appropriate, although Mrs. Barker reportedly was not enthused about the name. However, before Taghkannuc could be adopted officially, other names were proposed.

The Rutland Historical Society secretary, Dr. John M. Currier, actively promoted Neshobe as a fitting name for the island. An Indian scout of that name had helped the Green Mountain Boys stop General Burgoyne's march south in 1777. Neshobe had reported enemy movements and fought alongside the colonists.

Mr. G.D. Spencer, in *Early History of Lake Bomoseen*, stated, "No human being ever bore the name of Neshobe" and pointed out that Dr. Currier was only a recent resident of Rutland County. In spite of opposition, the name Neshobe won out. Herbert O. Allen, the great-great-grandson of early settler Colonel Noah Lee, "smashed a bottle of milk against the rocks of the

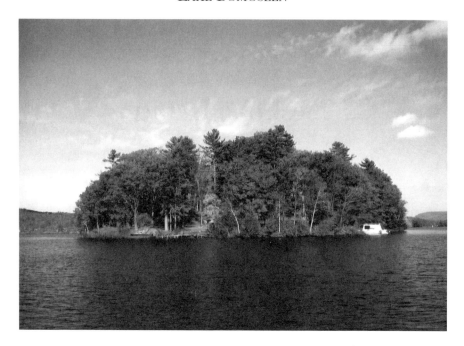

Neshobe Island appears tranquil and colorful in the fall of 2007, seen looking north. *Courtesy of the author.*

island…and the chairman then pronounced that the island shall here forth be known as Neshobe."

Although President James Garfield had just been shot on July 2, the Fourth of July celebration was held as planned on Mason's Point. It was reported that about fifteen thousand people witnessed the ceremonies on a beautiful summer day. The steamer *Naomi*, pulling a specially built barge, ferried three hundred people at a time in eight trips to Mason's Point. Train passengers went directly from the Hydeville Station to board the *Naomi*. Speakers gave historic addresses all day, including a long poem about Lake Bomoseen delivered in Welsh by Mr. R. Walters. At the end of the day, a large rock at Mason's Point was dedicated as "Celebration Rock," and the festivities concluded with fireworks set off from a raft in the bay east of Mason's Point.

The Barkers' Taghkannuc House, provided summer accommodations and could be reached by steamer from Hydeville three times a day. Mrs. Barker had the reputation of being an excellent cook. G.D. Spencer gave her high praise: "The fried frogs legs she gave me were equal, if not superior to, any I ever obtained at Delmonico's [the famous New York restaurant]."

Robert Mason cleared the island sometime after 1782 and planted Indian corn. When the corn matured, Mason brought his hogs over to feed on the

The Story of Vermont's Largest Little-Known Lake

TAGHKANNUC HOUSE,

Taghkannuc Isle, Lake Bomoseen, Castleton, Vt.,

A. W. BARKER, Proprietor.

Three miles from Hydeville depot; five miles from Castleton depot; three miles from Johnson's bridge.

A steam boat decked over all, four water tight compartments, capable of carrying one hundred, will be upon the lake in 1883; make three daily trips from Hydeville to the island, Walker's, Coffee's and the bridge.

No lovelier resort can be found in America.

Nine acres in the island, devoted to lawns, groves, walks, etc.

Fine air; no dust or heat. Charges reasonable. New York papers, one o'clock P. M., publication day.

Three miles to the Russell House, Hydeville.

This advertisement promoting Barker's Taghkannuc House, appeared in an 1882 booklet by G.D. Spencer entitled *Early History of Lake Bomoseen. Courtesy of Castleton Historical Society.*

corn and forage for acorns, but this hog-raising venture was not successful. The hogs were homesick and attempted to swim back to Mason's Point. "On their way over they cut their own throats with their sharp hooves and bled to death before reaching shore," said John M. Currier in a Castleton Historical Society booklet. During the first half of the nineteenth century, the island was used to grow rye, wheat and peas and to pasture sheep, but any attempts to raise hogs, horses or cows failed, as these animals invariably tried to swim to Mason's Point.

The first house on the island was built near the southern end by S.H. Langdon in 1835. This one-story, thirteen-feet-square building was completed in one day using rough boards floated over from Mason's Point. It was used for fishing parties and chowder gatherings. Around that same time, an icehouse was built for use by summer visitors at no charge. Local work parties held an "ice bee'" in the winter to fill the icehouse, and Mr. Langdon provided dinner and two gallons of rum to the volunteers. Several years later, both of these buildings burned to the ground.

In 1878, John A. Leggett built a two-story house that was later expanded by A.W. Barker. It became one of Lake Bomoseen's first resorts for summer guests. He also built a little cottage on the southwest promontory two years later, and he cleared brush and built a road to make it easier for guests.

Perhaps Neshobe Island's most colorful period lasted from the 1920s through the early 1940s, when it was a retreat for the famous Algonquin Round Table. This group of literary and theatrical personalities originally met at the Algonquin Hotel in New York City. The group was founded by Alexander Woollcott, a drama critic, author and actor who wrote reviews for the *New York Times*. He also had a radio program, *The Town Crier*, which helped advance the careers of many aspiring writers and actors. Woollcott had been introduced to Lake Bomoseen by his financial advisor, Enos Booth. Mr. Booth owned Neshobe Island and other nearby property on the lake. After seeing the island, Woollcott immediately envisioned its potential as a summer retreat and, with his friends, purchased half of the island, including a small cottage and a large barn. Mr. Booth, a New York lawyer, had built the small two-story house that became known as "the Clubhouse."

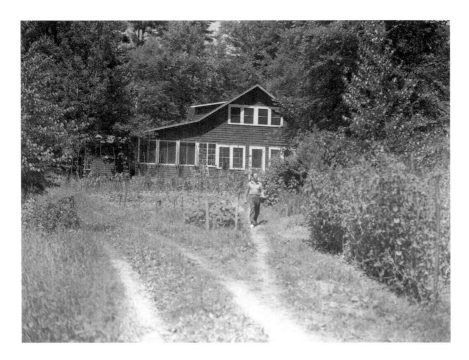

Alexander Woollcott and his Algonquin Round Table friends enjoyed this simple cottage, "the Clubhouse," on Neshobe Island from the 1920s to the early 1940s. *Courtesy of Richard Brown and the* Rutland Herald.

At first, the Clubhouse had no electricity or running water, which didn't concern Woollcott, but eventually other members of the group convinced him to put in more modern amenities. Woollcott and ten associates jointly owned the western half of the island; the rest was still owned by Mr. Booth. Booth began constructing a fieldstone house on the island's highest point, on the eastern side that he owned, but Woollcott objected. Eventually, they came to terms and the stone house was finished by the summer of 1937. Horses were used to bring the stone across the ice during the winter. This house became Woollcott's permanent residence for much of the last seven years of his life. Letters from Woollcott suggest that he did stay on the island during some winter months. Today, the house consists of three bedrooms, a library, a study, a large living room with a fireplace, three bathrooms of green-veined Vermont marble, pantries and a well-equipped kitchen.

The Neshobe Island Club Inc. was a select group consisting of about ten members at a time. Members paid a $1,000 initiation fee and annual dues of $100. Members of this exclusive private club made up Woollcott's innermost circle of theatrical and literary friends. In comedian Harpo Marx's

The Clubhouse, with the stone house in the background, as it appeared circa 1930s. *Courtesy of Davene and Jerry Brown.*

1961 *Vermont Life* article, "Buckety-Buckety into the Lake," he mentions that one became a member by being asked to be a guest for a second time. "I was invited up for a weekend. I was invited again which put me in a class with Alfred Lung, Lynn Fontane, Ethel Barmier, Katherine Cornell, Noel Coward, and Theodore Roosevelt Jr. Then I was awarded the final honor, I became a member." In this era before air conditioning, these well-known personalities welcomed the opportunity to retreat from the heat and hectic city to the cool breezes and tranquility of rural Vermont.

To describe Alexander Woollcott as a host would be a study in contrasts. He could be generous, witty, charming and amiable to his guests, but he was also eccentric, opinionated, controlling and self-centered. He was highly competitive and did not lose gracefully at any competition. After losing a game of chess, he was known to throw the ivory chess set in the air and stomp off to bed. He thought nothing of awakening a houseguest in the middle of the night to read something he had just written. He disliked if his guests overindulged in alcohol and normally did not do so himself. On one occasion, a noted author took a female companion ashore for an afternoon of drinks and committed an unforgivable breach of Neshobe etiquette: they missed croquet and dinner. Woollcott was so miffed that he refused to go get

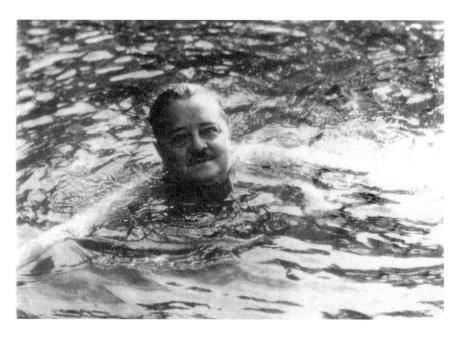

Alexander Woollcott enjoys a 7:00 a.m. dip in Lake Bomoseen, which was mandatory for his guests, regardless of the cool water temperature. *Courtesy of Davene and Jerry Brown.*

them, even when a storm blew up. The famous writer was never invited back, but the lady was eventually forgiven and welcomed back into the circle.

Woollcott had a prescribed daily routine. Everyone was required to take an early dip in Lake Bomoseen, no matter how cold the water. Afterward, breakfast was served, prepared by a local cook. This meal could go on for hours, as Woollcott held court and engaged guests in lively discussions. Between the end of breakfast and dinnertime, guests could swim, sail, fish or play cribbage, badminton and croquet, "Neshobe Island style." When Harpo Marx first visited the island, he had thought of croquet as an innocuous children's game, but he was soon to learn otherwise. Woollcott took it very seriously and played for keeps with cutthroat cunning and accuracy. There was no such thing as going out of bounds. If one were so unlucky as to hit the ball through the trees into the lake, "You had the choice of playing it out or placing it on the beach and losing a turn," recalled Harpo.

Another popular pastime during cocktails before dinner was "Murder." Guests drew lots to see who would be the murderer and who would be the

Alexander Woollcott is shown poised for a shot in one of his legendary games of croquet. *Courtesy of Davene and Jerry Brown.*

district attorney. The murderer's identity would be a secret until he or she said to the victim, "You are dead." The victim would then remain motionless until the others noticed, and the district attorney would try to discover who the murderer was. Woollcott would not allow anyone to eat dinner until the victim had been located. One evening, club members couldn't find the victim until 11:00 p.m. Finally, the group located author Alice Doer Miller in the back bathroom, where she had been holed up for hours after discovering "You are dead!" written in red lipstick on the toilet paper. By this point in the evening, Woollcott was extremely annoyed, especially since he felt that Marx had violated the rules by not confronting the victim face to face.

Stories of bizarre and outlandish behavior on the island abounded. For the most part, the native Vermonters took it all in stride and, if anything, welcomed the trade and publicity that Woollcott and his guests brought to the area. They became used to glimpsing famous people like Harpo Marx, Helen Hayes, Irving Berlin and Walt Disney. The general consensus was that they were eccentric but harmless, and the locals respected their privacy. However, summer tourists and curiosity seekers often brought their boats close to the island, hoping for a glimpse of the rich and famous. One such time, Harpo Marx became so annoyed with these rubberneckers that he stripped off his clothes, smeared himself with mud, brandished a club and did a war dance on the beach. "The tourists rowed away fast enough to have won the Poughkeepsie Regatta," wrote Harpo.

On another occasion, Dorothy Parker arrived for the weekend wearing nothing but a garden hat. Ms. Parker was known not only for her wit and her eccentricity; she was subject to moods and often sought solitude seated on a marble slab under a tree. The Neshobe Club members cherished their privacy, although it was often hard to maintain with such proximity to the other lake resorts. In spite of occasional interruptions, many of them found their stay on Neshobe a time of rest and inspiration as they completed screenplays or rehearsed their lines for an upcoming play.

Another amusing story involved a local schoolteacher hired as a waitress on the island for the summer. A famous Hollywood couple, unmarried, arrived to stay and requested to share a room. Sensitive to local morals, Woollcott decided to tell his young employee that the couple had been married secretly. All went well until news of their actual engagement hit the newspapers. The young lady evidently didn't see it, but after the stars departed, Woollcott and his manager contrived to keep the news of the marriage off the island by intercepting the newspapers and claiming that the radio had inexplicably broken until the headlines faded.

The Story of Vermont's Largest Little-Known Lake

This cozy tree seat was a favorite spot for Dorothy Parker when she sought solitude. *Courtesy of the author.*

William Bull, a fishing guide on the east shore, provided boat transportation to and from the island and delivered supplies. To notify the island of guests' arrival or important messages, he would raise a red flag. The *Fair Haven Era* reported the arrival of some especially illustrious guests on August 1, 1940:

> *A sizeable gathering of Lake Bomoseen guests and summer residents convened at Bull's Dock on Wednesday evening to await the arrival of Vivien Leigh, wife of Laurence Olivier, when she and Mr. Olivier arrived in company with Alexander Woollcott. The party was driven to Mr. Woollcott's island camp in William Bull's new speedboat, "Neshobe."* [The article went on to remind readers of Miss Leigh's recent "extraordinary portrayal" of Scarlett O'Hara in *Gone With the Wind*.]

Alexander Woollcott, shown with unidentified friend, enjoyed being pulled in his Japanese rickshaw on Neshobe Island. *Permission of Culver Pictures.*

The Story of Vermont's Largest Little-Known Lake

In spite of the exclusive company that he routinely entertained on the island, Woollcott did not set himself above the local residents. In fact, he became involved in the community, serving as a trustee for the town library and donating many review copies of books he had received.

During the summer of 1942, Woollcott's heart began to fail and few guests came to the island. As his health declined, Woollcott decided to find a rickshaw to use on the island. They advertised in papers as far away as Chicago before locating one close by. A former missionary to Japan living in Windsor, Vermont, had one for sale. Woollcott bought it and enjoyed being pulled around the island. Woollcott died at age fifty-six of a heart attack while doing *The People's Platform* radio broadcast. Thus ended the Neshobe Island Club era. At the time of his death, Woollcott and nine club members owned half the island and the other half was owned by his business manager, Joseph Hennessey. Joseph and Helen Hennessey eventually acquired the entire island and owned it from 1943 until 1964, using it as their summer home. One of the first improvements they made was to install a telephone, a modern convenience that Woollcott had always resisted, fearing it would infringe on his privacy.

In 1964, Mr. Hennessey sold the island to Merritt Chandler, a retired executive of Xerox Corporation from Rochester, New York, for $35,000.

Davene and Jerry Brown, the current owners of Neshobe Island, pose in front of their 1937-era stone house. *Courtesy of the author.*

The Chandlers enjoyed the island for over thirty years; each of their three children was married there on the lawn. After the death of Midge Chandler, Mr. Chandler put the island up for sale, and in 1998 it was sold to Davene Sheridan Brown.

Since acquiring the island ten years ago, Davene and Jerry Brown have done a lot of restoration. The foundation of the Clubhouse was replaced, and the interior has been restored to what it was when the Algonquin Round Table met there. The small building off the main Clubhouse was Woollcott's study, where he could work without interruptions. The oldest structure on the island, the barn, has also been restored. The famous croquet games were played between the barn and the Clubhouse.

Davene Brown has an extensive collection of books and memorabilia that describe what life was like on Neshobe Island during the 1930s, the heyday of Woollcott and his friends. Jerry Brown has renovated inside and out, from the natural woodwork to constructing a new water drainage system. He also was responsible for the bargelike boat built from an old oil tanker that they used to transport large items back and forth.

Neshobe Island seems to have cast its magical spell over all its owners. Davene Brown says, "The island is a special place. We wanted to have the kids be on the water, learning water sports…You can feel the energy of what has gone before here. It is a restful and peaceful place. You don't feel like you are the owners, but rather the caretakers of the island." When pressed for anything that might be considered a disadvantage for living there, she mentioned the problem of accumulating trash such as cans and bottles, because everything that comes on must be carried off the island. Like many Lake Bomoseen homes, the house is closed during the winter months, due to the difficulties of getting back and forth.

—

CHAPTER 4

Rabbit Island
and Page Point

In addition to Neshobe Island, Lake Bomoseen contains another smaller island called Rabbit Island. It got its name from a colony of rabbits that were stranded on the island when a sudden thaw melted the ice connecting it to the nearby mainland. When area settlers discovered the rabbits, they hunted them for food. This three-acre island is a slate ledge with only a thin layer of topsoil.

In 1901, Frederick Warren, an electrical engineer from Yonkers, New York, bought the island for $700,000. He subsequently married Rose Hyde, a member of the founding family of nearby Hydeville. The Warren family used the cottage on the island as a summer home for over fifty years, 1901–54. After a two-day drive from New York City, they would stock up on groceries and travel by boat to the island, which was only accessible from the channel. They kept several boats at a boathouse on the creek in Hydeville. When the Warrens bought it, the cottage boasted indoor plumbing, but Mr. Warren wanted to keep the island pristine and unspoiled so he took out the indoor toilet and replaced it with an outhouse. There was no electricity, so the family cooked on a wood stove and used oil lamps for lighting. The house had six rooms, including a main room with a fireplace, three bedrooms below and two small rooms upstairs. Around 1930, the Warrens had a small prefabricated Sears and Roebuck house kit floated over on a barge for a guest cottage.

Life on Rabbit Island was very simple. There was a dock and boathouse on the southern end, where the shallow water provided good swimming for the children. The family and their friends enjoyed boating, walking, gathering wildflowers, games and picnicking. The family traveled by boat to get their mail every day, and the children looked forward to stopping at the store for ice cream and candy. Mrs. Warren's father, Russell Hyde, visited frequently. So did Mr. Coffee, who lived on the mainland and kept the family supplied

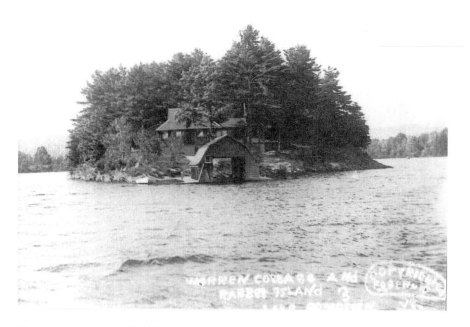

The Warren cottage on Rabbit Island was owned by that family for over fifty years, 1901–1954. *Courtesy of Sheila MacIntyre.*

with ice, fresh vegetables, milk and the latest news. The Warrens' dog, Jerry, was very much a part of the family. When he died, Mr. Warren buried him on the island with his name carved on a marker.

In later years, instead of coming all the way up the lake, the Warrens came across the narrow channel between Rabbit Island and Acorn Lodge on the mainland. Acorn Lodge is one of the oldest cottages on Lake Bomoseen and one of the few examples of the older style summer home that still exists today.

By 1954, the Warren children were off on their own and Mr. Warren began to find the upkeep too much, so in 1955 he sold the island to a Princeton University professor, Harry Hazard, otherwise known as "Hap Hazard" to his students. Professor Hazard owned it until 1976, when it was sold to Dr. Donald and Sheila MacIntyre, who had just sold their cottage at Little Rutland on the east shore. Shortly after acquiring the island, the MacIntyres had purchased a new mattress and were waiting to be transported to the island. George Chandler was not there to meet them as planned, and when they asked what had happened, they were told that everyone had gone up to Rabbit Island to fight a fire! The fire was started by newly installed power and telephone lines that had been strung too tightly. By chance, a pilot flying

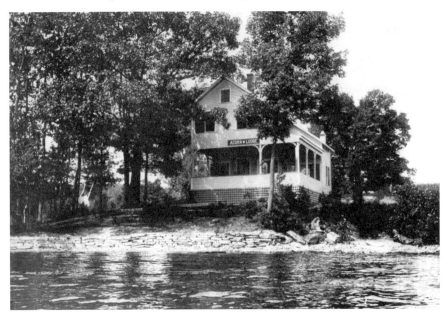

In the early 1900s, the Adams family owned this cottage, Acorn Lodge, on the northwest shore of the lake. It is separated from Rabbit Island by a narrow channel. *Courtesy of Rutland Historical Society.*

overhead saw the smoke and called it in. Fortunately for the MacIntyres and the local fire department, the ice had gone out the day before, enabling a water pumper to reach the island. Over four acres burned and a privy was destroyed. The grass was singed within a few feet of the guesthouse, but it and the main house were saved.

The MacIntyres lived on Rabbit Island for eleven years. The children were very young when they first came to the island—one, three and five years old. In spite of the occasional inconveniences of living on an island, it was a wonderful place for the children to spend their summers. They played among the pine trees that grew all over the property and were intrigued by a large uprooted tree on one end of the island. Sheila MacIntyre describes the north end as "forest primeval," untouched by previous owners. The children were encouraged to create their own amusements, and they built fairy houses out of sticks and the plentiful moss. Overnight, "the fairies" would reward their efforts with treats. Eventually, it became a burden for the MacIntyre parents to keep slipping out at night to purchase candy.

During their years on Rabbit Island, the family saw little in the way of wildlife, mainly birds and raccoons that stole the family's sweet corn off the back porch one night. In spite of the island's name, they only saw one rabbit.

At one point, Dr. MacIntyre became concerned about sightseers or local people climbing up and jumping off the cliff into Eagle Bay. He erected a cross that read "Jerry is buried here," referring to the previous owners' dog. He hoped that the sign might deter daredevils, who would assume that Jerry was a hapless human who died while attempting to dive. In spite of his concerns, diving off the cliff became a rite of passage for the MacIntyre children, their cousins and friends. The water was very deep in Eagle Bay, and there were three levels of jumping-off spots. As the youngsters got older and more confident, they could progress up the cliff to a higher spot.

Other than having electricity and a telephone installed, life for the MacIntyre family was much the same as it had been for previous owners. They refurbished the main house and guest cottage, which was rented out to summer visitors. Dr. MacIntyre, a dermatologist in Rutland, commuted back and forth daily. He would bring trash such as disposable diapers to his office to be disposed of, and he filled empty milk jugs with drinking water to take back. Later, an ultraviolet water purifier was installed to make the lake water fit to drink. Laundry had to be carted to the mainland to cut down on

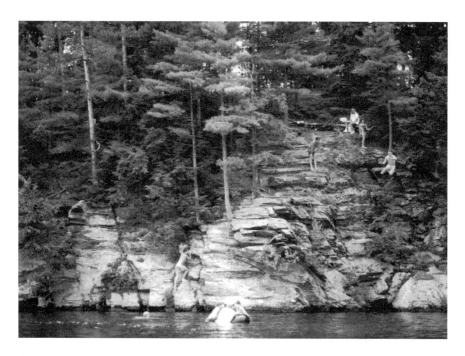

Diving from the rocks on Rabbit Island was a rite of passage for the MacIntyre children. *Courtesy of Sheila MacIntyre.*

the loads of wash. Sheila MacIntyre encouraged the kids to wear bathing suits much of the time, and she instituted the "Dirty Award." The child whose pile of freshly laundered clothes was the smallest received a dollar.

Sheila MacIntyre shared a favorite family story about their life on the island. She had purchased an old piano for only $20, but getting it to the cottage proved to be challenging and expensive. They finally had to have an elevator built, at a cost of $1,000, to get the piano up on the island. They thereafter referred to the piano as "MacIntyres' Folly." She painted it blue and they enjoyed playing it for years. The family cherished the simple pleasures of an island summer home until 1986, when it was sold. That owner retained it for only a year and then sold to David M. Geeter of Connecticut. The Geeters made further improvements, including a septic system, but retained some of the previous owners' possessions: the Warrens' large oak dining table, a collection of books from Professor Hazard's era and the infamous blue piano, "MacIntyres' Folly."

Since 1986, Sheila MacIntyre has lived in a house that dates from 1883, located near Rabbit Island on a promontory called Page Point. Much earlier, the Indians called it "Watch Point" because from that site overlooking the lake they could spot deer swimming across. The original deed goes back to the time when only the Johnsons and the Spooners lived west of the Float Bridge. The deed grants the owners of the house on Page Point right of way through Spooner land "as long as the rivers flow and grasses grow."

Sheila MacIntyre is the fourth owner of the old house on the point. Judge Page, from New York State, built the house, the first "camp" on the lake, in 1883. While he lived there, three New York State governors stayed in the second-floor dormer room at various times.

The second owners of the house on Page Point were the judge's daughter and her husband, Elizabeth and Colonel Thomas. Elizabeth wrote a book there while recuperating from a broken leg. It was entitled *The Tree of Liberty* and later made into a movie. The Stevensons from Long Island became the third owners and sold to the MacIntyres. The house commands a magnificent view of the lake, and it retains the charm and personality of a bygone era, increasingly rare on the lake at the present time, when so many of the old camps and cottages have been torn down or extensively remodeled.

The Lake House/Trakenseen Hotel

In 1882, Richard H. Walker constructed the first hotel on the east shore, the Lake House. It was located half a mile south of Coffee's, on the lakeshore. The hotel contained twenty-one rooms. The basement level provided a picnic area, and the first floor housed the office, dining room, parlor and kitchen. Bedrooms were on the second and third floors. It became a popular place for events. The June 28, 1906 edition of the *Fair Haven Era* mentions a family reunion of sixty-five descendants of William Preston, who served in the French and Indian and Revolutionary Wars.

When Mr. Walker and his wife died after almost thirty years of ownership, the Rutland Railway, Light and Power Company purchased the resort in 1912. This company was already operating the Lake Bomoseen trolley park across the street from the Lake House.

For the better part of two decades, the power company ran the amusement park that brought hundreds of people from Rutland for special events such as Fourth of July celebrations, special outings, company clambakes and dances. However, by 1918, the cost of running the spur line to the amusement park brought an end to service and the hotel was purchased by Charles K. Ballard.

An interesting piece of memorabilia from the Lake House when it was under R.H. Walker's ownership is a program for a Christmas dance held on December 25, 1884. The program was printed by the Tuttle Company of Rutland. Guests arrived by horse-drawn wagon to hear Parker's Orchestra play thirty dance numbers, with supper served at intermission. Ladies had their dance cards filled in with partners for each dance, ending with a selection titled "Morning Star" and then "Home Sweet Home."

During the late nineteenth and into the early twentieth century, the Lake House lobby housed the Bomoseen Post Office until it was moved to Coon's Store in Castleton Corners in 1914. When Red and Valerie Poremski purchased the Trakenseen Hotel in 1959, the wall of small mailboxes was

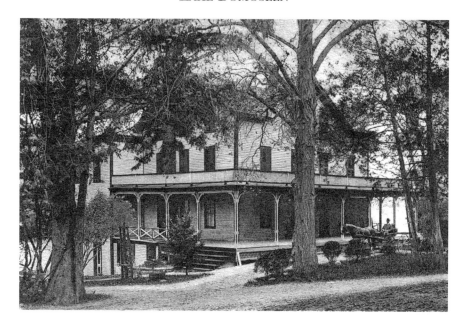

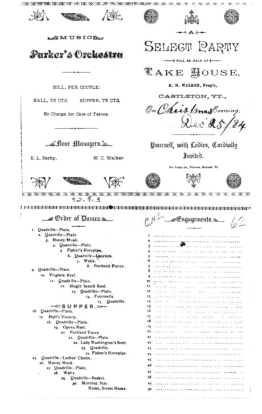

Above: This postcard, postmarked August 20, 1907, shows the first hotel on Lake Bomoseen's east shore, the Lake House. *Courtesy of the author.*

Left: For only $1.50, couples could enjoy supper and a Christmas dance at the Lake House, with "free parking" for their horses, as shown in this 1884 program. *Courtesy of Castleton Historical Society.*

The Story of Vermont's Largest Little-Known Lake

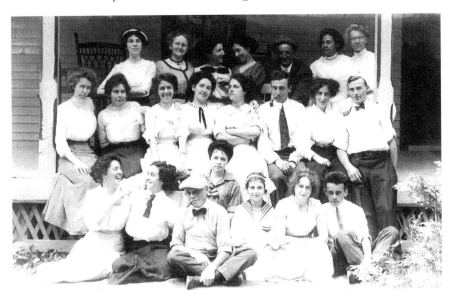

A group of Lake House employees posed for the camera in 1911. *Courtesy of Robert Woodard.*

still there, a reminder of the day when Bomoseen was a little village with many businesses catering to tourists.

In 1912, the Rutland Railway built a large rectangular addition on the west side of the Trakenseen Hotel, but before the addition could be built, land had to be reclaimed from the lake, so teams of horses pulled slate from the quarry at Cedar Mountain over the ice. The shallow shoreline was filled in with slate and leveled with cement so the foundation could be put in. This foundation lasted sixty-nine years, but before the building could be modernized in 1981, cement footings had to be poured to stabilize the structure. At that time, owners Red and Valerie Poremski had the top two stories of the addition removed, creating a two-story building with efficiency units to include more modern amenities.

During the period before World War I, the Lake House was renamed the Trakenseen Hotel. Many people today believe this was an Indian name, but in reality the name was created by combining the names of Tracy and Kennedy, partners who ran the hotel. They took the first three letters of their names and added "seen" for Bomoseen.

By 1920, the Trakenseen Hotel was leased and later purchased by Charles K. Ballard, who reopened it after World War I. Six years later, Mr. Ballard sold the hotel to Leo P. Quinlan and Earl E. Barrett of Ausable, New York, who had worked with Mr. Quinlan's brother for thirteen years. During Leo

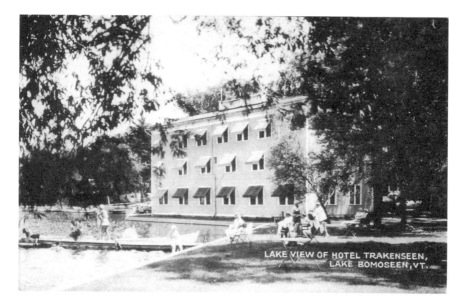

This photo of the Lake House shows the large rectangular addition, complete with awnings, built in 1912. *Courtesy of Richard Wilson.*

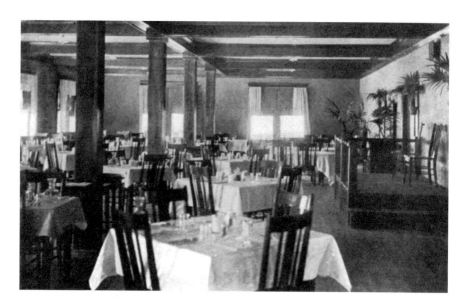

The Trakenseen, formerly the Lake House, featured a spacious dining room. *Courtesy of the author.*

The Story of Vermont's Largest Little-Known Lake

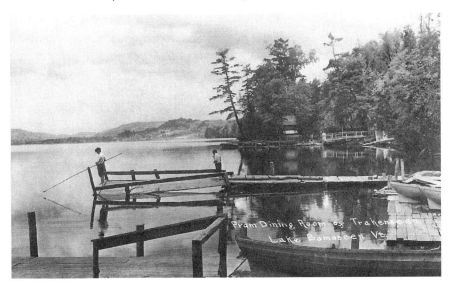

Patrons at the Trakenseen had this dining room view of fishermen trying their luck. *Courtesy of Linda Splatt.*

P. Quinlan's tenure, two ten-room cottages were added and running water was installed in all the rooms of both the hotel and the cottages. By the time of Leo P. Quinlan's untimely death in the fall of 1930, the Trakenseen facility could accommodate 140 guests.

From 1929 to 1932, starting at age fourteen, Anna Guyette Hewitt worked at the Trakenseen Hotel as a chambermaid, waitress and laundress. Mrs. Hewitt, aged ninety-two in 2006, recalled in an interview:

> *I first lived with my family above the Castleton Village Store, from when I was five years old until my aunt got me a job at the Trakenseen Hotel as a chambermaid. It was then that I began living with my grandmother at Castleton Corners, and each day I would walk the three miles up the road to the hotel. At the beginning of my time at the Trakenseen, Earl Bennett's wife Marie was head waitress and all the workers were from surrounding towns except for the hotel chef, Murray, who was flown up from Jacksonville, Florida, for the start of the season on Memorial Day.*

During the early 1930s, the three main hotels—the Trakenseen, Cedar Grove and the Prospect House—took turns holding formal dances. These were in addition to the three dances a week held at nearby Gibson's Crystal Ballroom. Both Anna Guyette Hewitt and her friend Martha Langdon Towers recalled in an interview seeing guests all dressed up to attend the

dances at the Cedar Grove Hotel in the afternoons while they were working at the laundry:

> *We got dressed up in the dorms for the employees of the Trakenseen and went to the dance, even though the employees of the Trakenseen were forbidden to go into the other hotels. We danced and had a good time. Once a gentleman I had seen several times offered me a cigarette and I took it, thinking it was the social thing to do. I coughed so much he took it back, saying, "You don't have to smoke that."*

Both Mrs. Hewitt and Mrs. Towers recalled that washing sheets in the hotel laundry across the street from the hotel was not especially pleasant on a hot summer day. It was next door to Parker's saddle horse stable, with its pungent odor of horse manure. The photograph below, taken by LeRoy H. Parker, shows the stables patronized by guests from all three hotels. People would ride along the trails following the shoreline.

Martha Langdon Towers and Anna Guyette Hewitt waited tables three times a day during their years as employees of the Trakenseen. Mrs. Towers reminisced:

> *I worked at the Trakenseen after graduating from high school at age eighteen and stayed ten years, until I got married in 1940. We worked for fourteen*

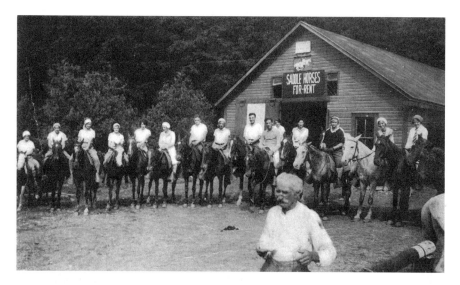

Riders lined up at Parker's Stables for a trail ride along the lake. *Courtesy of the author.*

dollars a month for three months and hoped for good tips, like one I got from a lawyer from Albany. Many of the guests were seamstresses from Troy, New York, and the surrounding area, and they put on airs but tipped poorly. We wore uniforms like you see in the photo of me, with a cap and apron. We got enough to eat, but nothing special. I recall one time that Murray, the black chef, prepared a pork chop for me after the meal had been served. He told me, "Hold on, little one, and I will have a chop for you later." I believe he did this because my boyfriend at the time used to hunt frogs for their legs and had cooked some for Murray over a bonfire at Crystal Beach. Chefs Murray and Wally and a third chef lived near the stables in a separate building from the other employees.

Both Martha Langdon Towers and Anna Guyette Hewitt enjoyed waiting on such celebrities as Harpo Marx, Dorothy Parker and Helen

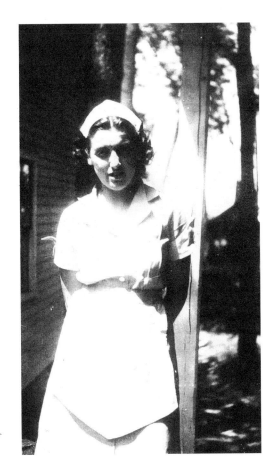

As a young woman, Martha Langdon Towers worked summers as a waitress at the Trakenseen, as shown in this 1936 photo. *Courtesy of Martha Langdon Towers.*

Hayes when they came to the Trakenseen for dinner. Martha Langdon Towers recalled occasionally being hired to drive guests to Kinni Kinnic on Lake St. Catherine in her car. They also described the colorful fisherman, William "Bill" Bull, who ran a boat livery just north of the hotel. He often ferried Alexander Woollcott and his guests to Neshobe Island and also ran boat tours of Lake Bomoseen for guests at the hotels. He had a school of tame bass that he hand-fed next to the Trakenseen dock for the guests' entertainment. Anna Guyette Hewitt and Martha Langdon Towers both now reside not far from Lake Bomoseen. Anna lived in Schenectady for a time, where her husband had found employment. She remembered, "During the years we were raising our family, we came back to Lake Bomoseen during the summer. My husband built a cottage at Neshobe Beach, and we enjoyed the popular dance floor that belonged to the Neshobe Beach community."

By the 1950s, the Trakenseen was owned by Jack and Irene Menning, who liked to mingle with the guests while the staff took care of day-to-day operations. The kitchen staff was made up mostly of black Floridians who came up north when the Trakenseen opened on the Fourth of the July for the season. They worked all summer until the resort closed after Labor Day. Then they returned south to work at hotels in Florida for the winter until the Trakenseen opened again the following summer.

In 1957, Red and Valerie Poremski from Florence, Vermont, concerned about the future of the family farm, decided to purchase the Edgewater Inn from Harry Riley. Valerie Poremski had taken summer boarders at the farm and had enjoyed it. As Roz Rogers, Valerie Poremski's daughter, recalls:

> *My mother had worked for two seasons at Eddie's Snack Bar as a teenaged girl and was impressed with all the resort activity at Bomoseen. She saw purchasing the Edgewater as a chance to become part of this activity. At that time, the Edgewater was the only place on the lake that would take people on a nightly basis instead of weekly, Saturday to Saturday. Some of the big bands, like Sammy Kaye, would stay at the Edgewater after playing at nearby Gibson's Crystal Ballroom.*

Two years later, the Poremskis used proceeds from the sale of their farm as a down payment on the Trakenseen. The hotel property came with several outbuildings, including a gift shop just south along present-day Route 30. They sold a variety of souvenirs and Vermont products such as maple syrup, wooden bowls, chests and marble items, all with a sticker proclaiming "Made in Vermont." This shop would later be torn down, and Frank's Place

The Story of Vermont's Largest Little-Known Lake

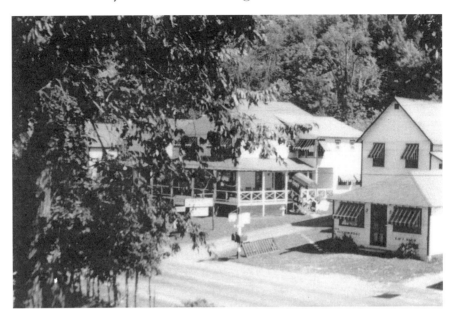

The Edgewater Inn was one of the first hotels to take in guests on a nightly basis instead of weekly. A gift shop and a barbershop were located in the building on the right. *Courtesy of Tom Mazzariello.*

souvenir stand took its place. For a few years before the Poremskis owned these hotels, Tom Mazzariello had a barbershop next to the gift shop. In the photo above, the Edgewater Hotel is on the left and the smaller building on the right housed the gift shop and barbershop.

Roz Rogers told a story about Mrs. Menning. During the property transfer from the Mennings to the Poremskis, Mrs. Menning remarked, as she signed the papers in the hotel dining room, "This is my table." Valerie Poremski thought she meant that the table was her personal property and she would be taking it with her. However, she discovered that Mrs. Menning really meant that it was the table where she sat and ate with the guests, served by the hotel staff. "My mother could not imagine such an arrangement," Roz commented. "To her, guests were held on a higher plane, and should be addressed properly with their last names, regardless of age."

The Poremskis made improvements to the hotel, adding showers and upgrading the lighting fixtures. Most of the guests at the hotel in those days were middle-class people from the urban centers, such as metropolitan New York City, who wanted the fresh air and quiet countryside. These guests would often stay at one hotel one time and a different one the next, but the Poremskis

created a loyal clientele through activities and friendly competition, such as golf or softball games held between the hotels. Other popular activities were scavenger hunts, hay rides, horseback rides and card parties. Being new to the hotel business, the Poremskis tried novel ideas to foster guest loyalty and camaraderie that brought them back season after season, well into the 1960s, when other establishments were seeing fewer guests. Roz Poremski Rogers was twelve years old when first coming to Lake Bomoseen:

> *It was my job to set up the greased watermelon races in the lake, and I was also in charge of the cookout lunch down by the lake. This was a great success because the guests did not have to dress up and could eat hot dogs and slices of watermelon in their swimsuits. I singed my arms so many times over the wood fires that the hair has never grown back!*

Under the Poremskis' ownership, guests received three daily meals, Saturday to Saturday. Every night featured some kind of entertainment. On Monday nights wiener roasts and singalongs were held, Tuesday was bingo night, Wednesday a horse racing game was set up on an oilcloth-covered ping-pong table and on the weekends an accordion player or a musical combo performed in the dining room, with tables and chairs pushed back to create a dance floor.

The Trakenseen had a porch that stretched across the front, and as guests walked in the front door they faced three large open areas, one of which contained the check-in counter. During the Poremski family years, the kitchen was located on the floor below the dining room, so waitresses had to go up a ramp with their trays of meals. Before the Poremskis owned it, the hotel kitchen was divided into areas for the pastry chef, the salad maker and other specialized tasks. In the 1950s, the Poremskis opened up the kitchen to make it more efficient and hired local help, no longer depending on the seasonal workers from Florida. The dining room was very simple, with oak tables of varying size draped with white linen cloths. Lucky diners who secured a window table could enjoy a beautiful Lake Bomoseen sunset as they enjoyed their meal.

During their early years of ownership, the Poremskis used the original hotel to house their employees, with girls on the top floor and boys on the second floor above the dining room and lobby. Roz Rogers recalled with a smile, "My mother hired the daughters of friends and was watchful in preventing the male help from climbing up the fire escape to the girls. My father often slept on the couch all night with one eye open to catch any boys who might sneak upstairs!"

The Story of Vermont's Largest Little-Known Lake

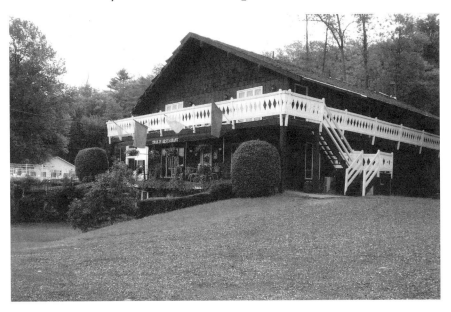

The Trak-In Restaurant as it appears today. *Courtesy of the author.*

By the early 1960s, guests continued to be housed in the four-story addition and the Trakenseen Hotel, but in 1962 the motel became the more popular place to stay because of air conditioning and television sets. To some extent, these improvements affected participation in group activities such as softball games. Around this time, people began to stay for shorter periods and they sought their own entertainment and leisure activities.

In 1973, the Trak-In Steakhouse was built and continues to operate today. According to Roz:

> *When it was first built, the Sirloin Saloon had just opened in Rutland, specializing in steaks and a salad bar. My parents thought it would be a good idea to copy, so they featured their own sirloin steaks and salad bar. This decision proved to be an instant success, as more and more people came from their privately owned cottages to the only air-conditioned steakhouse for miles.*

Today, the Trak-In Restaurant is open to the public seven nights a week for dinner and also has breakfast available. The restaurant and the lawn by the lake are popular spots for wedding receptions and other events. The friendliness and personal attention, as well as the excellent menu, have

continued to keep the Trak-In a popular lake establishment from its earliest beginnings as the Trakenseen Hotel to the present time.

During the more than fifty years under ownership by the Poremski family, the Edgewater resort complex has continued to evolve. The four-story Trakenseen addition was demolished in 1981 to make way for modern two-story efficiency units. The older building lacked the modern amenities that guests had come to expect. The original hotel closest to Route 30 became the site of the Poremskis' family home. The two-story motel added in 1962 with air conditioning and TV sets was an instant success. The chalet structure was added in 1973. The old Edgewater Inn still houses guests. It is the oldest hotel still in continuous use on the lake.

The Trolley
and Bomoseen Park

During the late nineteenth century, prior to the widespread use of automobiles, the large hotels on Lake Bomoseen were well served by the railroad lines. In 1882, a group of Rutland businessmen petitioned the Vermont state government to pass legislation to form the Rutland Railway, Light and Power Company. This company would provide trolley service between Rutland and West Rutland, with frequent local stops that were too costly for regular steam locomotive service. The Central Vermont Public Service Corporation completed laying track within three years, and the service was inaugurated on December 13, 1885.

The first months were a challenge due to severe winter weather and the expense of purchasing and maintaining the horses to pull the trolleys. However, the first seven months were financially successful, so the company reduced the fare for the route by 20 percent. By the summer of 1894, the Rutland Street Railway Company introduced electricity to the line, which enabled the company to lower operating costs. New electric cars replaced the horse-drawn ones and provided faster service. The increased ridership of the trolley service to West Rutland encouraged an extension of the line to Fair Haven. The new line went through the valley from West Rutland to Castleton, following the natural land contours. No stations were built along this stretch, so passengers simply waited alongside the tracks for the trolley to come along and paid the fare onboard, similar to some train stops today.

In 1902, the line to Fair Haven was begun, and a branch to Poultney was added later. In June 1903, work began on another trolley branch to Bomoseen Park. The following year, a substation was built at Castleton Corners to power the trolleys going to Fair Haven and three miles north to Bomoseen Park, an early amusement park built by the trolley company. During the early part of the twentieth century, in many regions of the country it was common for trolley companies to build amusement parks

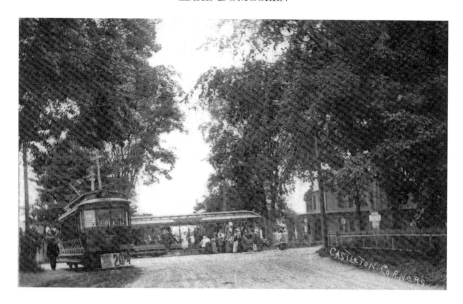

The Rutland Railway, Light and Power Company's trolleys brought thousands of visitors to the resorts. This photograph shows passengers boarding at Castleton Corners. *Courtesy of Linda Splatt.*

This rustic arch welcomed guests to the Bomoseen Park at the end of the trolley line, across from the Lake House. *Courtesy of Linda Splatt.*

near the end of their trolley lines to increase ridership. The Bomoseen extension ended in front of the Lake House within easy walking distance of the amusement park, Cedar Grove Hotel, the Prospect House and the adjacent steamboat pier.

The Bomoseen Park opened for the 1904 season. It did not feature a Ferris wheel or roller coaster like many larger urban parks of the time. It consisted of a Victorian dance pavilion, four small concession buildings, walkways lined with rustic benches, wooden swings and a baseball diamond. During its opening season in 1904, the park attracted a large crowd from Rutland for a clambake put on by the trolley company to celebrate the Fourth of July. The open-air trolleys were packed with passengers during hot summer days when people sought cool lake breezes and enjoyed picnics at the park. Upon debarking at the long wooden station, visitors strolled up the hillside past the concessions to the shady picnic ground furnished with wooden tables, benches and swings.

Between 1904 and 1918, numerous improvements were made to the park. East of the dance pavilion, a concrete platform with benches was built to provide a seating area for larger audiences at band concerts. To the south of the pavilion, a cone-shaped electric water fountain covered with decorative stones was added. This style of fountain was a novelty of the times; a similar one was built in the Fair Haven Park. The remains of

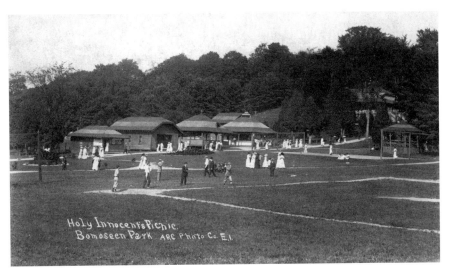

The Bomoseen Park was the site of many community events, such as the Holy Innocents Church picnic, circa 1915. *Courtesy of the author.*

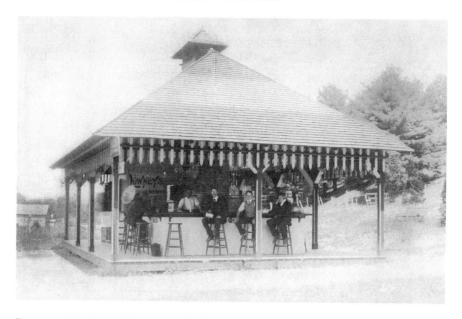

Patrons could enjoy refreshments at the Bomoseen Park concession stand. *Courtesy of Linda Splatt.*

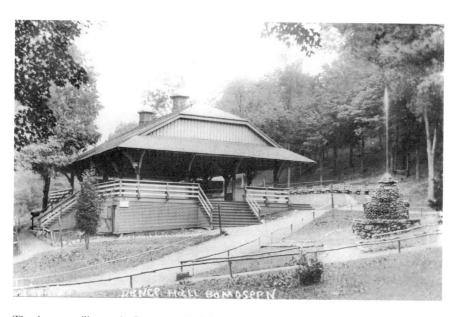

The dance pavilion at the Bomoseen Park hosted dances and band concerts. The electric fountain on the right was a novelty of the times. *Courtesy of Linda Splatt.*

the Bomoseen fountain can still be seen on the hill behind the Trak-In Restaurant.

Each summer Bomoseen Park attracted increasingly larger crowds for its July Fourth celebration. In 1905, the Independence Day festivities included three baseball games, a dance with a six-piece orchestra and fireworks at night. In 1906, the Howe Scale Company of Rutland and the Colombian Marble Quarrying Co. held a field day and picnic for their employees. Two thousand attended despite rainy weather. In 1907, an ad in the *Rutland Daily Herald* proclaimed, "Something doing every minute from 10 o'clock in the morning to midnight." On July 5, the paper reported that "fully 6,000 people visited Lake Bomoseen yesterday, this being the largest crowd that the electric railway company has ever carried to the lake in one day. During the afternoon the steamer *Arthur B. Cook* and numerous steam launches carried many people around the lake."

On July 6, 1908, a record-breaking crowd of thirteen thousand visited the park during a heat wave. The chief attraction was a military drill competition. After dark, the crowd was treated to a spectacular fireworks display. This same year, the park began providing fireworks, dancing and prizes for the annual boat regatta sponsored by the Bomoseen Yacht Club.

During the height of Bomoseen Park's popularity, one could ride the trolley from Rutland to Fair Haven or Bomoseen Park for $0.25 each way. The trolley chugged along at ten to twenty miles per hour. A typical summer schedule for trolley service from Rutland began at 5:30 a.m., and the last car back to Rutland departed at 11:55 p.m. In 1912, the trolley company enticed passengers by offering the first Saturday dance of the season for free. The Rutland City Band presented a concert the next day. In most years, the Rutland Railway, Light and Power Company's greatest profits were realized in the summer. Windows were removed for maximum ventilation during the summer months, creating open-air cars. Throughout the rest of the year, the trolleys provided transportation for non-boarding students at Castleton Normal School and a means for residents of Fair Haven, Castleton and Poultney to travel to Rutland easily for shopping or other errands. The trolley line also enabled workmen at the local marble and slate quarries to live farther from their jobs. They could commute more economically by purchasing tickets in bulk, seventy-five tickets for only $3.25.

A typical trolley ride from Rutland to Bomoseen Park was crowded with families and excited children chattering about the anticipated day's activities. Electricity crackled overhead as the trolley made its way to Castleton. Some passengers got off at this stop and the trolley continued on down Main Street. The line cut sharply to the northwest over a 1,500-foot-long wooden trestle

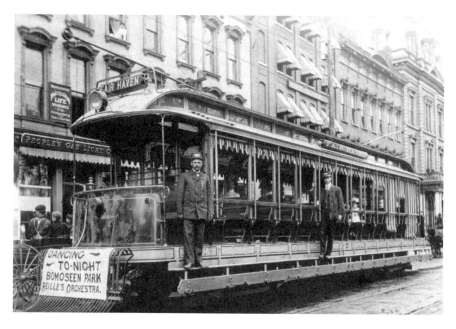

Open-air trolleys like this brought families to the resorts on hot summer days in the early 1900s. *Courtesy of Rutland Historical Society.*

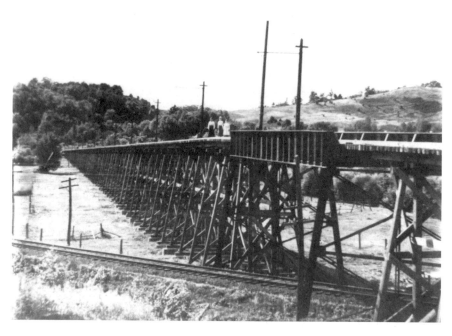

The trolleys rattled across this 1,500-foot wooden bridge just north of Castleton. *Courtesy of Castleton Historical Society.*

bridge 30 feet above the D&H tracks on the north side. The bridge creaked and groaned as the fully loaded open-air trolley rocked across the trestle. In 1910, the wooden bridge was deemed unsafe and a more substantial bridge replaced it. The picture here shows the trolley bridge, circa early 1900s.

Once the trolley reached its destination at Bomoseen Park, passengers disembarked for a day of fun. Due to the tight schedule, as soon as the last passenger got off, the conductor and motorman immediately turned the seats around and moved to the opposite end of the car for the return trip. The trolley could be operated from either end.

The trip back to Rutland from Lake Bomoseen at the end of the day was very different from the trip out. After picnicking and swimming all day, the families were relaxed, tired and subdued. Most of the younger children had fallen asleep by the time the trolley reached Castleton, if not sooner. Many memories of these trolley rides have been preserved. Carlton Wilson, at that time owner of Wilson's Clothing Store in Rutland, witnessed the burning of the Bomoseen House in October 1912, while on the trolley. In 1920, the Wilson family was returning from a picnic at Lake Bomoseen. Mr. Wilson's young son had found a small snake he wanted to keep, so his father put it in a box for the trolley ride home. During the trip, Mr. Wilson noticed other passengers staring intently at him and discovered that the snake had gotten loose and was curled over his shoulder! (This story came from a Castleton Historical Society tape, read by Martha Towers from Marsella Cassedy's *History of the Trolley Car*.)

The trolley service was not without mishaps, however. One accident occurred when the motorman allowed the trolley to gain too much speed as it was crossing the long trestle over the railroad tracks. The trolley jumped its track as it reached the bottom, causing minor injuries to those aboard. In 1904, a lone gunman shot at the trolley coming into Castleton. Fortunately, the motorman was not hit and there were no passengers at the time. The shooter was apprehended by the sheriff the next day. In a bizarre accident on September 28, 1916, Robert Morris lost his life when he was struck by three trolleys. The *Fair Haven Era* reported that Mr. Morris's nephew had run after the trolley and caught it, but his uncle fell down between the tracks and was hit by the eastbound trolley and two others.

In its heyday, the Rutland Street Railway Company was very successful. The spring 1964 issue of *Vermont Life* stated that "its 35 miles of track carried at one time the greatest number and variety of cars of any system in Vermont, and its trolleys for many years carried more passengers than any other line in the state." In spite of this success, by 1917 the Rutland Street Railway Company was facing bankruptcy, as operating costs increased and

Dave Rogers stands on what remains of the dance pavilion floor today. *Courtesy of the author.*

the volume of riders decreased. In 1916, the company ran its final car from Castleton Corners to Lake Bomoseen. The last Fourth of July celebration at Bomoseen Park was held in 1917, attended by a large crowd, even though the Bomoseen trolley line spur was no longer operating. That year people still flocked to dances and baseball games held at Bomoseen Park, never dreaming that they would not continue. On January 16, 1918, an article in the *Rutland News* informed the public that Bomoseen Park was closing and would not reopen the following season. During the summer of 1918, the trolley tracks were torn up for the steel needed for the war effort.

What became of Bomoseen Park? The dance pavilion was transported to the Rutland Fairgrounds and used for dances and exhibitions before it burned down in 1970. The remains of the electric water fountain and the dance pavilion's concrete platform can still be seen on the hill behind the Trak-In Restaurant.

It was a struggle to keep the rest of the trolley line operating. In 1917, the Poultney extension was leased to the Vermont Slate Belt Railway and the fare was increased from five to six cents. In spite of another fare increase to eight cents in 1921, the company continued to show a deficit. At one point in 1922, the Rutland Railway, Light and Power Company tried to increase ridership by reducing fares. In September 1924, the Vermont Slate Belt

Railway bought the trolley line, and the last electric rail car to travel from Rutland to Fair Haven did so on September 27, 1924.

A number of factors were responsible for the demise of the trolley line that had brought thousands of people to the lake and upon which workers, students and local citizens had depended for a cheap means of transportation. By the early 1920s, automobiles had caught on with the public and mass production had made them more affordable. Roads were being improved, and families could now travel faster, more easily and at their own schedule. Between 1912 and 1917, three fires had destroyed much of the business community in Castleton, so people traveled by car to Rutland and other communities to shop.

The concept of erecting an amusement park at the end of a trolley line to attract customers was not unique to the Rutland area. Ridership typically fell off on weekends, so the trolley companies needed to come up with something to attract weekend passengers. Shortly after the turn of the twentieth century, many cities throughout the nation saw such amusement parks built, but few survived the rise of the family automobile and the financial disaster of the Great Depression. While it lasted, Bomoseen Park was the place to be during the warm summer months to enjoy the water, cool breezes, picnics, sports, concerts and dances.

The Rutland Railway, Light and Power Company, so instrumental in the development and popularity of Bomoseen Park, still lives on as Central Vermont Public Service Corporation, which provides electricity to Rutland County. Currently, both politicians and the public are examining alternate fuel sources and public mass transit to alleviate dependence on increasingly expensive oil. Perhaps one day we will come full circle, as we look back at the inexpensive service that the trolley lines provided in the previous century.

The Prospect House

The Prospect House was built in 1888 by William C. Mound on a fifty-acre peninsula, as pictured on the next page near the end of its existence. The original four-story building could accommodate 175 guests. Under a succession of owners, additions to the main building and eleven cottages were added, making it Lake Bomoseen's largest resort.

During its early years, the Prospect House offered its guests entertainment. The July 31, 1891 *Poultney Journal* described a "hop," or dance, held there as the "swell affair of the season," with sixty-five couples in full evening dress in attendance. "Dancing was kept up until the wee small hours with a brief intermission when ice cream and refreshments were served."

On November 17, 1893, the same paper reported that the property changed hands:

> *The Prospect House on Lake Bomoseen, owned by Thomas Mound, was exchanged for the Bomoseen House and the Sanford tenement house in the village owned by Horace Dwyer of Rutland…next season Horace B. Ellis will manage the Prospect House. The Prospect hotel has been the most successful hotel on the lake for the past three years.*

In 1894, Horace B. Ellis took over the management of the Prospect House. In 1891, he had built the Ellis Park Hotel on the west shore, but it mysteriously burned in March 1894. The July 27, 1894 *Poultney Journal* described the attributes of the Prospect House, including its beautiful location on a point overlooking the lake, use of electricity and its clientele of guests from near and far. "Mr. Ellis surrounds himself with a phalanx of the best help he can find and plenty of them."

After Horace B. Ellis died in 1915, his wife and son Edward continued to run the hotel until 1922. The *Fair Haven Era* had a front-page story in its

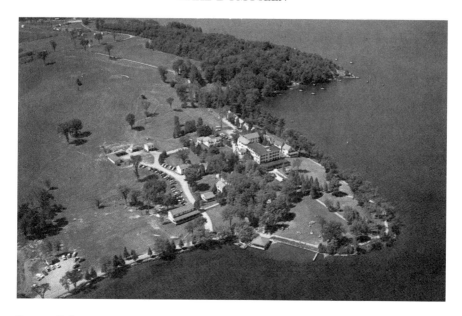

Prospect Point as it appeared in the mid-1900s. *Courtesy of Forward's Color Production, Manchester, Vermont, author's collection.*

September 7, 1916 issue, reporting, "The social event of the season at Lake Bomoseen was the marriage of Miss Stella Dyer Ellis to Walter E. Snow of East Orange, New Jersey, at the Castleton Federated Church."

During the early twentieth century, the Prospect House was the most expensive of the lake hotels, compared to the Cedar Grove and Trakenseen on the east shore. Rates ranged from twelve to twenty dollars weekly for two persons and seventeen to twenty-five dollars per week for a single person. Guests may have been willing to pay a little more due to the wide variety of activities offered by the Prospect House: a nine-hole golf course, a fleet of twenty-five boats kept in the hotel's one-hundred-foot-long boathouse, a nearby riding stable, children's activities and games such as billiards, croquet, baseball and bowling. Many guests participated in the inter-resort tennis matches and other sporting events, with trophies provided to the winners.

The pictures opposite show the Prospect House as it appeared at the turn of the twentieth century, with the addition built by Horace Ellis. The message on the reverse of the first postcard, sent to Mineola, New York, mentions that "Jack" enjoyed golfing. The second postcard depicts the grand veranda that wrapped around the hotel. The expansive view gave guests the feeling that they were seated on a large ship about to sail across Lake Bomoseen.

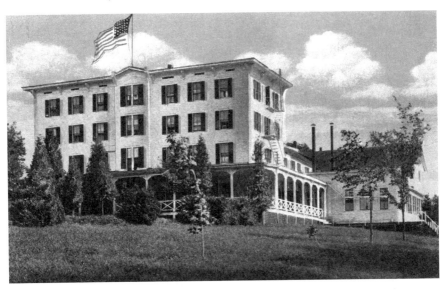

The Prospect House as it appeared in its heyday. *Courtesy of the author.*

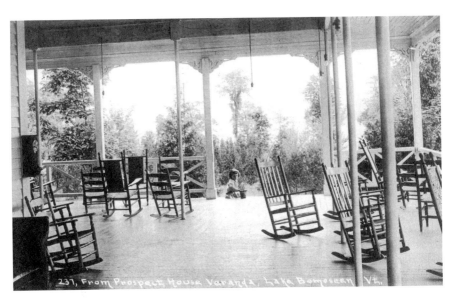

A collection of rocking chairs invites relaxation on the Prospect House's veranda. *Courtesy of Robert Woodard.*

Fish stories never seem to go out of style. During much of the twentieth century, Lake Bomoseen was renowned for its large- and smallmouth bass, trout, northern pike, perch and sunfish. In an interview, Rex Hayes related the following story from his time as maître d' at the Prospect House during the 1930s: "Almost every evening, Louis Wagner would bring a big fish he'd caught that day into the dining room and would get my permission to parade it through the tables to show off his catch on its way to the kitchen. Then the black cooks would prepare it for him." Fishing remains popular today, but some once-plentiful species such as walleye, perch and whitefish can no longer be found or have become scarce in Lake Bomoseen's waters. Long after the summer cottages have been closed up for the season, fishing enthusiasts erect shanties on the frozen lake, hoping to pull a big one through the ice.

The photo below, sent to Plattsburgh, New York, was also taken in front of the Prospect House veranda and shows a fisherman proudly showing off his big northern pike. The message reads, "We are all having a fine time at this place."

During the early 1900s, all three east shore hotels prospered due to excellent transportation. For a fare of less than ten dollars round trip, guests traveled by train from New York City to the Castleton Depot, where Prospect House employees transported them by horse and wagon to the hotel. Until 1916, people could also pay fifteen cents for a forty-minute trolley ride to Castleton Corners and, for another dime, transfer to the trolley line that went to the east shore resorts.

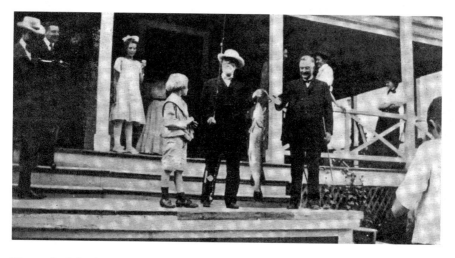

The catch of the day at the Prospect House drew admiration from onlookers. *Courtesy of the author.*

The Story of Vermont's Largest Little-Known Lake

The December 1, 1921 issue of the *Fair Haven Era* announced the sale of the Prospect House to Loren R. Johnson, manager of the Ormond Hotel in Ormond Beach, Florida, for $50,000. Mr. Johnson was a native of Fairlee, Vermont, and he had many years of experience with hotels in Florida and New York City. His tenure as owner lasted only three years, however, and John Quinlan and Howard Hart took over the hotel in 1924. John Quinlan often traveled between his several hotel holdings by seaplane from Prospect Bay. After Quinlan's untimely death in 1937, the Hart family continued to have interest in the hotel for the next forty-two years. When J. Howard Hart died in 1966, Mrs. Harriet Baker and her husband, Charles, ran the hotel until the mid-1970s. The Hart family also had owned the Trakenseen and Lake Dunmore Hotels.

During its years of existence, the Prospect House continued to attract a wide clientele. It became a regular rendezvous for New York politicians, including John Thoefel, the Democratic leader of Queens County, and Queens County judge Thomas Kadien. Businessmen from metropolitan New York City and their families would often stay for two months. The wives and children remained in Vermont while the breadwinners commuted back to the city during the week. Besides all the activities that drew guests, the meals were renowned. A full breakfast, including a choice of four fresh fruits and various entrees, was served from 7:30 a.m. to 9:30 a.m. daily. Dinner featured such entrees as turkey, roast beef or steak. Rex Hayes, in a 1992 interview with Elihu Fryzell (featured in *Beautiful Lake Bomoseen*), commented that guests got so much to eat early in their stay that they gradually ate less and less.

While the Prospect House and the other hotels provided an escape from the heat of urban centers for summer visitors, for local residents the resorts were a source of employment. Teachers or students on summer break from Castleton Normal School eagerly sought summer jobs to supplement their incomes. It was often hard work with long hours. Waitresses at the Prospect House served three meals a day, seven days a week, and they were responsible for cleaning the dining room and washing silverware at their stations. They were required to purchase two sets of uniforms—blue with red trim for the first two meals of the day and yellow dresses with white aprons for the evening meal. The employees of the Prospect House generally had better accommodations than at neighboring resorts. Men stayed in "Tammany Hall" and women had separate living quarters in "the Dormitory."

The groundskeepers and some of the cooks and other hotel staff were African Americans who came up from Florida to work for the summer season. Rex Hayes remembered they liked to play cards and gamble when

their work shifts were over, and the card games would go on into the wee hours of the morning in their living quarters.

Rex Hayes started working at the Prospect House at the age of eighteen and continued there for about thirty years. A teacher and later a principal by profession, Rex returned each summer, moving up from his start as a waiter to become the maître d'. Among his duties as maître d', besides supervising the dining room, was raising and lowering the flag each morning and evening. Rex recalled that while the dining room staff worked seven days a week with no days off, the money was considered to be good, especially during the Depression. Once he became maître d', he earned about fifty dollars a month, far more than he could as a farmworker for eight dollars per week. Waitresses and bellhops were not tipped until the end of a guest's stay, to ensure good service. "At the end of their stay, guests would shake my hand and slip me a tip, pat me on the back, and say, 'See you next year.' I anticipated the tip but it was not expected I acknowledge it," Hayes said in an interview.

During the Prohibition era of the 1930s, alcoholic beverages were not served in the hotel dining room. Illegal liquor was smuggled down from Canada by boat on Lake Champlain and went from Whitehall to New York City by vehicle. But some of it remained locally and was consumed by area customers. Federal agents made raids on Neshobe Island and at local residences. On one occasion, according to Rex Hayes, an area home was

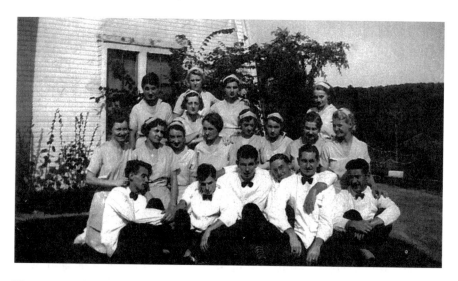

The summer of 1933 Prospect House staff posed for this picture. Rex Hayes is on the end, first row, left side. *Courtesy of Holly Hitchcock.*

Educator by winter and maître d' by summer, Ralph "Rex" Hayes posed by the water's edge at the Prospect House. *Courtesy of Holly Hitchcock.*

searched but the illicit liquor was hidden down a well in the basement and never found.

In the 1930s, the *Rutland Herald* featured events planned for the summer season at the resorts around Vermont. On July 11, 1936, a news article reported that Governor Charles M. Smith had been a guest at the Golden

Jubilee dinner commemorating the fiftieth season of the Prospect House. The governor was quoted remembering previous visits there and congratulated the current proprietors, John J. Quinlan and J. Howard Hart, on "the development of Lake Bomoseen into one of the most popular and complete resorts in the state." After dinner, the guests enjoyed a play performed on the new shuffleboard court, and the governor was given an ornamental key to Lake Bomoseen.

The summer of 1944 was Jerry Grady's first season to work at the Prospect House as a dishwasher. In successive summers, he worked as a waiter and remembers taking breakfast orders to the kitchen and bringing out hot rolls, griddle cakes, jelly omelets and a variety of fresh fruit. Chef Fred Watson's philosophy was to let people eat as much as they want, but his wife, Darnell, would remind him, "Remember, we're going to feed them, not fatten them!" Jerry recalled that his summer earnings as a youth were used to buy his school clothes, and he was able to buy his mother a ton of coal for the winter heat.

During the 1940s, the help was discouraged from mingling with the guests. Dances were held every Wednesday evening on the large veranda, and Jerry recalls some of the employees would sneak in to dance. Employees were not allowed to swim in the lake near the hotel until after 5:00 p.m. One of Jerry's most vivid memories was of V-E Day, the end of World War II in Europe. "The cooks came out of the hotel banging on their pots and pans, food was served outside on the lawn and fireworks were set off at night. Many people went to Mass at the nearby Our Lady of the Lake Chapel."

After World War II, change came to the resorts around the lake. Many longtime clients felt that the new generation of younger employees was not as committed and dedicated to their jobs and that the service and condition of the dining room was not up to its previous standards. Guests' habits began to change as well. With increased automobile ownership, people stayed at the hotels for shorter periods and traveled more frequently. The sense of community that had existed when guests stayed all summer and returned year after year began to disappear. The heyday of the Lake Bomoseen resorts was declining. The Prospect House, however, continued to operate beyond the World War II period, into the 1970s. Near the end of its existence, Bryan Kelly worked there for four years, doing a variety of jobs such as laundry, general maintenance and golf course upkeep. He recalled that the guest occupancy dropped off each subsequent year from a high of 250. He received room and board while working there, and to him it felt more like a vacation than working. In contrast to earlier eras, by the 1970s society was more relaxed and now employees were expected to mingle with the guests, participating in activities such as softball games and comedy nights.

Bryan narrowly escaped injury one day while on the job. While he was on the riding mower doing grounds maintenance, "I had so much lawn to cut, and the mower was going so slow, I fell asleep and drove right into the lake, in spite of people hollering at me to stop." Bryan survived this embarrassing moment but the mower was not so lucky. He also worked a stint as a night watchman from 10:00 p.m. until 6:00 a.m. His predecessor had been fired for accidentally discharging his gun. He did not last long at this job as he could not get used to working nights and sleeping during the day.

One of Bryan's most humorous stories was about a time he was the object of a practical joke. Two fellow employees obtained some elephant dung from the circus that was performing at Bomoseen Golfland on Route 30. They deposited it in one of the hotel toilets and called upon Bryan to fix the clog. He didn't appreciate the mess, but the two perpetrators laughed uproariously. Bryan told the hotel proprietor, who made the culprits do the cleanup. However, it backfired on Bryan when he jokingly asked his boss, "How did the elephants get in the bathroom, anyway?" His supervisor was not amused and fired him, although he was rehired shortly after.

After his four years as a Prospect House employee, Bryan Kelly later worked for a short time at the Cedar Grove Hotel at various jobs, including breakfast cook. He remembers the sky at 5:00 a.m. being black with bats. He

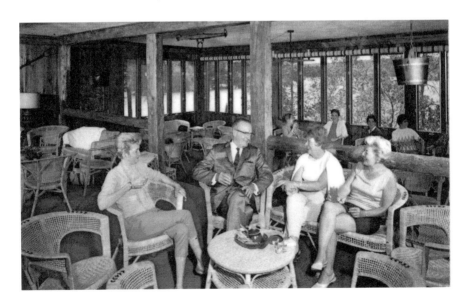

In its later years, the Prospect House added this cozy cocktail lounge, the Sugar Shack, to attract customers. *Courtesy of Linda Splatt.*

also recalled the Somewhere II Restaurant at the Cedar Grove and worked for Red Poremski at the Trak-In Restaurant. Near the end of its existence, the Prospect House opened the Sugar Shack, a casual setting where patrons could enjoy a cocktail, joining a trend by the other hotels, which already had cocktail lounges.

What is on Prospect Point today? Now in the early twenty-first century, the hotel, cottages and the large boathouse on Prospect Bay are long gone, after having been landmarks for nearly eighty-five years. In recent years, homes have been built on the knoll overlooking the lake and plans are being discussed for condos near the nine-hole golf course, which currently remains in operation.

The Ellis Park Hotel, 1892–1894

For about one hundred years, little was known about the Ellis Park Hotel until a chance find by Sue Lyman, the Castleton Elementary School librarian. While renovating her house, she discovered an 1893 promotional brochure about the Ellis Park Hotel in the wall. She gave it to Joseph Doran, a social studies teacher at Castleton Village School and a past president of the Castleton Historical Society. The document is now in the historical society's archives.

In 1890, John A. Barrett and family from Brooklyn, New York, spent the summer at Mound's Prospect House on the east shore of Lake Bomoseen. The following summer, the family stayed at the Bomoseen House in Castleton. John Barrett's father lived in Rutland, and John believed there was a grand future for additional hotels along the lake. He was attracted to the former Reyson farm located on a plateau seventy-five feet above nearby Avalon Beach, just east of Cooksville. In August 1891, he acquired a half interest in the land owned by Horace B. Ellis and persuaded Mr. Ellis that they should build a four-story hotel accommodating 175 guests. The hotel and surrounding property were christened Ellis Park.

According to an 1891 *Poultney Journal* article, the grounds on the south and east sides of the plateau were

> laid out in lawns, drives, flower beds, and shrubbery...On the grounds is a never-failing spring which will furnish pure water to every floor of the building...On the land are already about a dozen buildings which will be converted into necessary outbuildings which consist of laundries, ice houses, stables. etc.

By the end of August 1891, the dimensions of the hotel had been staked out and the cellar excavation had begun.

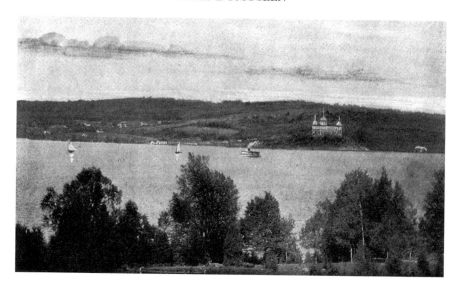

This panoramic view shows the Ellis Park Hotel in April 1893, from a promotional brochure. *Courtesy of Castleton Historical Society.*

The hotel was designed by Frank Davis of Castleton under the supervision of Horace B. Ellis and John A. Barrett. The *Poultney Journal* of October 2, 1891, reported, "Ellis and Barrett are pushing things on their new hotel at Ellis Park. Every available workman is at work upon it, and there is no doubt but that it will be ready for the plasterers within the time set."

On June 21, 1892, the *Journal* was able to report that "the new Ellis Park Hotel was formally opened last week with a good number of guests…The new steamer is in constant demand already, and is in all respects a great improvement over the old one." The new steamer was named the *Arthur B. Cook* after the owner's son and could carry two hundred passengers from the pier near Hydeville train station to the resorts up the lake.

An 1893 promotional brochure contained a map showing only railroad lines and no roads; during this horse-and-buggy era, the fastest way to travel to the lake from major cities such as Albany, Boston or New York was by train. Many guests departed from New York City on the 9:00 a.m. express train to Albany. From there they took a Delaware and Hudson train to Hydeville, arriving about 4:00 p.m. Others took the night steamboat from New York City to Albany and then the train to Hydeville. From Boston travelers could take the Saratoga Express to Fitchburg, Bellows Falls and Rutland and finally arrive at Hydeville without having to change trains. From the Hydeville Station guests went by horse and carriage or the *Arthur B. Cook* to their final hotel destinations on the lake.

The Story of Vermont's Largest Little-Known Lake

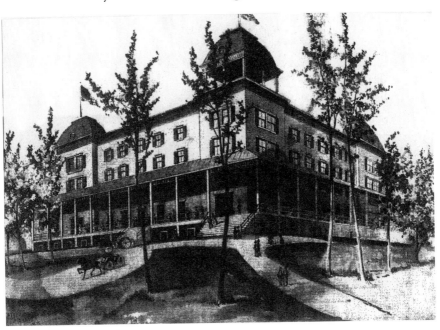

The Ellis Park Hotel was an impressive sight, with its spacious veranda and towers. *From an 1893 promotional brochure, courtesy of Castleton Historical Society.*

Upon reaching Avalon Point, guests traveled up the private road to the hotel on the plateau by horse-drawn carriage. The gracious hotel, situated in a 150-acre park, must have looked very welcoming after the long journey. Guests checked in at the office on the southeast corner of the hotel before being taken to their rooms. The first floor of the hotel was surrounded on the south and east sides by a sixteen-foot-wide veranda and had a spacious parlor and a grand thirty-five- by eighty-nine-foot dining room. Tall French windows in the dining room could be opened to access the cool lake breezes, an important feature during the days before air conditioning.

Every room in the hotel looked out on nature. Guests lucky enough to book rooms on the eastern and southern sides had a lake view, but even on the northern and western exposures guests had a pleasant view. The hotel featured an open courtyard behind it. The main staircase to the upper floors led up from the office. The hotel boasted modern amenities such as electricity, and as the *Poultney Journal* reported on May 20, 1892, "Bathrooms and closets are abundant on every floor." Unlike modern hotels, bathrooms were not located in every room. Most of the rooms were about the same size, except for those in the southeastern corner, which overlooked the lake on two sides.

Guests could relax and catch the lake breeze on the shady veranda.
Courtesy of Castleton Historical Society.

The hotel had three towers, and guests could climb up to the domed observatory, the largest of the towers. The observation tower rose 125 feet above the lake and provided a spectacular view. An American flag flew daily from the observation tower, and the hotel's pennant from one of the other towers.

The main floor's public rooms had fireplaces for the guests' comfort and enjoyment, especially when late summer or early fall evenings began to get cool. An 1893 Ellis Park Hotel promotional brochure writes that "the fortunates who still linger among the scenes of the summer's enjoyments gather in cozy circles, when music by the orchestra, song, story, laughter and rest fill the too quickly passing hours." The brochure also contains glowing testimonials from satisfied guests and claimed that the hotel's location high above any swamps was beneficial to the guests' health.

The Ellis Park Hotel seemed to rival modern resorts in that it offered a wide variety of recreational opportunities without having to leave the property. Guests could choose fishing, boating or swimming at a smooth, safe beach or relaxing in "cozy little summer pavilions and rustic benches and arbors." Those seeking active sports could play tennis on the courts located on a small plateau on the west side of the hotel or use the bowling alley in one of the outbuildings. Croquet and billiards were also offered. A stable was maintained for guests to go horseback riding or for buggy rides to nearby places of

interest, such as Hubbardton Battlefield. In addition to the local *Rutland Herald*, New York City and Boston newspapers were delivered by afternoon so out-of-town guests could keep up with the news. The 1893 promotional brochure advertised rooms at rates ranging from $12.50 to $38.00 per week, and rates for the entire season were also available. Daily rates were $3.50 and up per night, but most guests stayed more than one night.

During its first two years, the Ellis Park Hotel offered entertainment in the spacious parlor. Professor Van Arnum of Troy, New York, served as master of ceremonies at such events as a bean bag party and a children's carnival. In August 1892, guests appeared in full evening dress or in costumes they had created. Professor Van Arnum created a new dance especially for the hotel, called "La Pompadore." Besides this dance, guests did the sailor's hornpipe and danced around a Maypole. The September 2, 1892 edition of the *Poultney Journal* described the last social event of the season as "a complimentary to Professor Van Arnum, who has been master of ceremonies at the hotel this season."

In spite of a very successful first two years, in 1893 the Ellis Park began to experience a downturn. The September 9, 1893 issue of the *Journal* reported that "the Ellis Park Hotel will close the 15th of this month." During the winter of 1893–94, the hotel was closed up and none of the first-floor fireplaces was used, nor was the kitchen in use. In 1894, a full-scale nationwide economic depression hit.

On March 9, 1894, before the start of the tourist season, the Ellis Park was in ashes. The fire was discovered about eleven o'clock at night, breaking through the office and in back of the dining room areas. Destruction was swift; by midnight the hotel had collapsed. The *Journal* bluntly reported that the cause of the fire was incendiary. "It would seem from this fire following so closely upon the burning of the Hotel Hygeia that our summer hotels and cottages are in danger. The plan evidently is to rob the house of all articles that can be easily taken away and then to burn the property to cover the theft."

After the loss of the Ellis Park Hotel, it was discovered the owners had insured the building for only $12,500 and the contents for $4,000. The estimated loss was about $40,000. In addition to the two hotels already mentioned, another fire occurred on March 8, 1894. F.E. Mascott's paint and carriage factory burned to the ground. On May 18, 1894, a hearing regarding the Ellis Park Hotel and Mascott's carriage factory fires was held at the town hall. Mr. Mascott had hired a lawyer, H. Preston. The state's attorney, Mr. Jones, represented the insurance companies. He requested the room be cleared as it was a private hearing and no one had been arrested

THE POULTNEY JOURNAL.

MARCH 9, 1894.

ELLIS PARK HOTEL IN ASHES.

Another Summer Resort Goes Down—The Work of An Incendiary—Are All Our Summer Resorts Doomed? Why Not Offer Rewards?

The Ellis Park hotel on Lake Bomoseen was totally burned last night.

The fire was first discovered breaking through the office and back part of the dining room about eleven o'clock and the building fell in about midnight.

There have been no fires in the building this winter and so the fire is thought to have been incendiary. There was an insurance of $12,500 on the hotel, just enough to cover a first mortgage of $12,000 and interest, and an insurance of $4,000 on the furniture.

The loss is about $40,000.

The hotel was built about two years ago by Barrett & Ellis and ran by them the first season, after which Mr. Ellis retired and the second season it was conducted by Mr. Barrett with Mr. Boynton, formerly of the Berwick house, as manager. The first season was very successful and they made money, but the second season it was run at a loss.

It is a great loss to Castleton and especially to the lake, as it was an attractive hotel and had a fine location.

This March 9, 1894 news article mourns the passing of the grand Ellis Park, totally destroyed by fire. *From the* Poultney Journal, *courtesy of Castleton Historical Society.*

or charged. The court agreed, but Mr. Preston objected strenuously and refused to leave until escorted out by the sheriff.

No additional newspaper articles mention any court cases regarding the Ellis Park Hotel. From 1894 to 1901, the Marble Savings Bank struggled to find a buyer for the Ellis Park property. Finally on September 7, 1901, the approximate 145-acre property was sold to Edgar B. Moore, Richard Ryan and Charles W. Strobell, all from Rutland. Over the next three years, they divided the land into twelve lots. The three owners each retained one of the lots, and the remainder were sold to local or out-of-state people. The cottages built on the lots were mostly simple structures that featured porches facing the lake, and some made use of the remaining old Ellis Park Hotel outbuildings, including the Ellis Park boathouse, the bowling alley building and the stable. Initially, these cottages had no running water until wells were dug.

The cottage community became known as Avalon Beach. The three original owners in 1901 made it clear that anyone who owned land at Avalon Beach would have waterfront access. The Avalon Beach community was a place to relax and enjoy lakeside summer pleasures. For years the homes remained simple summer cottages, where people came to swim, fish and go boating. Today, most of the original twelve cottages have been

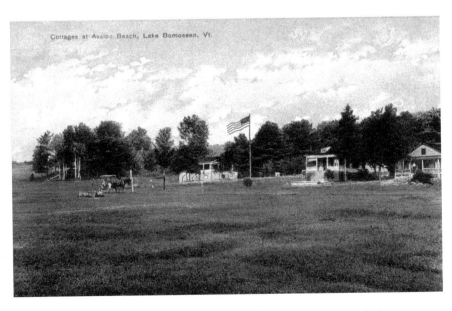

Three of the twelve original cottages that were built on the former Ellis Park site, now known as Avalon Beach. *Courtesy of the author.*

These two cottages were built from materials taken from the former Ellis Park bowling alley. *Courtesy of the author.*

modified and improved extensively or have been torn down and replaced with newer houses.

The Ellis Park Hotel complex included a boathouse located just north of Avalon Beach. This boathouse is likely the one that was brought on land and converted into a cottage at the Avalon Beach community. The two smaller cottages shown in the photo above were built using boards from the old Ellis Park bowling alley. Bowling scores can still be seen on some of the walls. For many years, the one in the foreground belonged to Bob Strobell, a descendant of one of the three men who purchased the land from the bank in 1901.

The Del Monte House and the Glenwood Hotel

During the 1890s, two different hotels were located on the west shore, just south of Point of Pines. In 1891, the newly constructed Del Monte House opened for guests. The July 17, 1891 edition of the *Poultney Journal* reported, "Hotel Del Monte is the name that will designate the new hotel now being built on the west shore of Lake Bomoseen. The name is said to be taken from an old Spanish hotel in Mexico. It is expected that it will be open for business in about two weeks." By midsummer, the Del Monte House was filled to capacity with fifty guests and people spoke highly of the accommodations and service. At the end of that season, however, on September 11, there was a serious fire at the dock in front of the hotel. The steamer *Harry M. Bates* was destroyed, and another nearby steamer, the *B.F. Pollard*, was scorched.

The Del Monte House was apparently quite successful following its opening; a June 2, 1893 article in the *Journal* proclaimed that the hotel was in "first class shape for summer trade." But less than three years later, the Del Monte was destroyed by fire early in 1896. Soon after, William C. Mound purchased twenty-five acres of land just south of Point of Pines that included the site of the former Del Monte House. Mr. Mound added two ells to an existing small, square building and named the new hotel the Glenwood.

William C. Mound had experience in hotel construction, as he had built the Prospect House about eight years earlier in 1888. The Glenwood was a huge place when finished, 175 feet long and 72 feet wide, including a large veranda that overlooked 148 feet of waterfront. The *Fair Haven Era* reported in 1896 that

the Glenwood is a three story building containing about 40 large airy rooms all done off in natural wood. The first floor is taken up with a large office, a parlor looking directly upon Bomoseen and the large and spacious dining

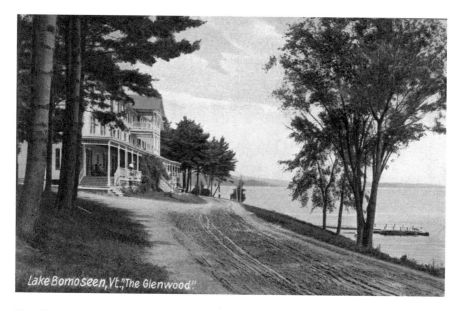

Lake Bomoseen, Vt.,"The Glenwood"

The Glenwood Hotel was located on Creek Road, on the lake's west shore. *Courtesy of the author.*

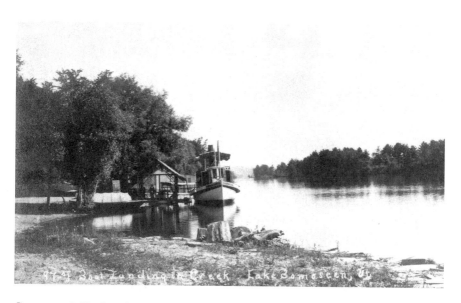

Guests traveled by boat from the boat landing on the creek (now the channel) at Hydeville. *Courtesy of Judy Crowley.*

room from the windows of which can be seen the lake. Water for drinking purposes is to be supplied by a large spring while a large [metal] tank will constantly be kept filled with water by a six horse power engine which will furnish relief in case of fire.

Given the fate of the previous hotel on the site, it is easy to understand why the engine-powered tank was worth noticing.

As illustrated by the turn-of-the-century postcard, guests arrived by boat. The *A.B. Cook* was a sixty-foot double-decked steamer that made regular trips to points around the lake. It left the boat landing in Hydeville at 1:00 p.m. and delivered passengers to Coffee's Picnic House beyond Crystal Beach and on to the various hotels, including the Glenwood. It is described in *Beautiful Lake Bomoseen*: "The steamer was painted white with a red stripe. Its nameplate was too short to accommodate the longer name, *Arthur B. Cook*, a later steamer which was longer." The *A.B. Cook* was a familiar sight on Lake Bomoseen from 1892 until 1903, when it burned and sank. Besides delivering passengers to the resorts, it was used for moonlight boat rides and other excursions. By the end of its existence it was owned by the Bomoseen Slate Company.

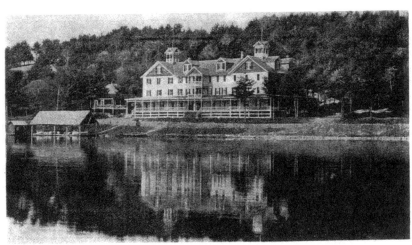

The Glenwood and Cottages on Lake Bomoseen.

Charming location on West Shore, 1 mile from Hydeville. Accomodates 200 gnests. Excellent Cuisine. Lake George Boats. Bowling Alley. Provision for Out Door Sports. Rates $2.00 per day, $7 to $14 per week.

W. C. MOUND. Proprietor. Hydeville. Vt.

This early advertisement for the Glenwood and Cottages gives an idea of its size. *Courtesy of Castleton Historical Society.*

As the early twentieth-century advertisement illustrates, the Glenwood had much to offer. The room rates ranged from two dollars per day to seven to fourteen dollars weekly, depending on the room's size and location. Lower off-season rates were offered in June and September. Just behind the boat livery for the "Lake George boats" the servants' cottage can be seen. Today it is the home of Mr. and Mrs. Thomas Doran.

During the 1911 summer season, some interesting events took place. As a prank, the steamer *Arthur B. Cook* was boarded one night by "several masked men with leveled revolvers who demanded that the boat be stopped and the captain submit to be bound hand and foot." Two captives were dragged to the rear of the boat, where they were presented with a new boat flag and a box of cigars in recognition of their popularity with the guests at the Glenwood. Captain C.E. Cook was rewarded for being "very accommodating about carrying the baseball team to the park for games with other hotel guests. He has also often taken the crowd for moonlight trips around the lake," the *Fair Haven Era* reported.

On a somber note, the hotel's owner, William C. Mound, died suddenly of a heart attack on August 30, 1911. He was awakened at 2:00 a.m. by a rowdy group just returning from a "straw ride and [they] were making a noisy demonstration," reported the *Era*. "Hurriedly dressing himself he started up the stairs to quiet the disturbance but had no sooner reached the top flight before he fell dead."

Near the end of 1911, the Glenwood was the scene of a burglary. Edward Clayton, a Glenwood summer employee, stole the key to the front door when the hotel closed for the season. He boarded with Mr. and Mrs. George Marshall of Poultney but could not pay what he owed them. One night in October, he suggested to Mrs. Marshall that they go to the hotel and take some bedding and other items, which she could keep in exchange for his room and board bill. She agreed to this unscrupulous plan, and after removing the bedding from the hotel, she cut the Glenwood name off the sheets and rehemmed them. Both were eventually arrested and sentenced to four years in jail for the robbery, according to a 1911 article in the *Era*.

After Mr. Mound's death, the Glenwood Hotel became the property of W.C. Wyatt, who managed a hotel in Troy, New York. At that time, the first floor of the four-story building contained the dining room, parlors, kitchen and a dance hall. The upper three floors contained guest bedrooms. Mr. Wyatt made numerous improvements in the spring of 1912, including painting all the buildings.

The 1912 summer season under Wyatt's ownership was very successful, but once again, bad luck in the form of a fire occurred. On September 17,

The Story of Vermont's Largest Little-Known Lake

1912, at 9:30 a.m., fire broke out in the kitchen area, and within hours the hotel was a smoldering ruin. It is believed that the fire started when Mrs. Davis, the chef's wife, spilled lard while frying doughnuts, according to a 1912 article in the *Rutland Herald*. When Mrs. Davis realized the fire was rapidly spreading to the rest of the hotel, she warned the two remaining hotel guests to get out. The first men at the scene from the nearby cottages only had a narrow garden hose with which to fight the fire. Fortunately there was no wind, so volunteer firefighters from neighboring communities were able to save the barn, cottages and outbuildings. They used a bucket brigade from the lake to douse the surrounding buildings and covered them with wet carpets. "The men were wrapped in soaked blankets enabling them to withstand the heat long enough to empty their pails of water."

In spite of the speed with which the fire spread, volunteers were able to save a number of items from inside the hotel, including table linen, bedroom furniture and the piano from the dance hall, before the walls collapsed into the cellar. At the time of the fire, the owner, William Wyatt, had only about $15,000 of insurance coverage, although the hotel was valued at $25,000. Without money to rebuild, Mr. Wyatt soon sold the property to Ellis N. Northrup of Castleton. An interesting side note on Mr. Wyatt's history is that shortly after the Glenwood fire it was learned that he had leased the Lake House from the Rutland Railway, Light and Power Company and planned to make it a year-round hotel catering to winter parties. Around this time, the Lake House had added an extensive fireproof addition made of

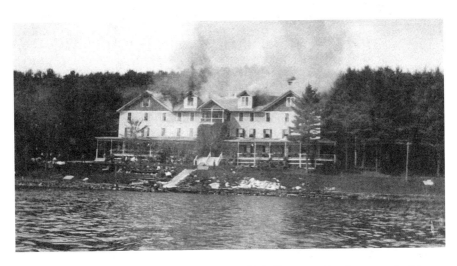

The Glenwood met the same fate as several other Lake Bomoseen hotels, as seen in this dramatic photo taken on September 17, 1912. *Courtesy of Richard Wilson.*

cement and steel. The May 24, 1917 edition of the *Fair Haven Era* reported that Mr. Wyatt was indicted on a charge that he had hired John D. Sharpe of Round Lake to set fire to his hotel at Hulett's Landing on Lake George on November 24, 1915. After deliberating for two hours, the jury acquitted him of the arson charge.

Ellis Northrup was quoted as saying that he would greatly prefer to have a hotel built on the Glenwood site and would try to interest someone in the project, but in 1918 he sold the only remaining Glenwood cottage to Jeremiah Durick and his family. This cottage had originally housed the Glenwood staff. From the time of purchase until his death in 1954, Mr. Durick made a hobby of restoring the cottage. He knocked down walls to enlarge the rooms and jacked up the foundation several times, as the cottage had begun to slip down the hillside. The Durick family enjoyed their life in the cottage, seldom venturing over to the east or "wild" side of the lake. They went for rides in their big boat, *The Shamrock*, swam at the little beach across the narrow dirt road or made a trip to Williams Store, just below their beach, for an ice cream soda.

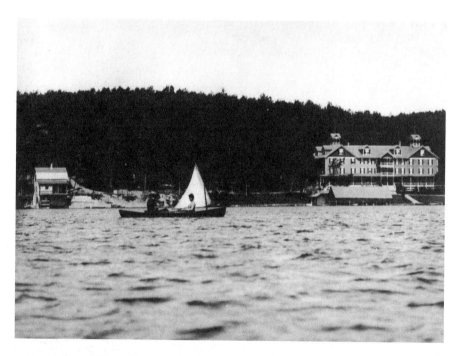

As shown here, Williams Store, on the left, existed at the same time as the Glenwood Hotel. *Courtesy of Thomas Doran.*

Above: Mr. and Mrs. Paul Fontaine own the former Williams Store building, now a summer cottage, and this original sign. *Courtesy of the author.*

Right: An original glass ice cream cone holder owned by Carol Senecal, whose father was caretaker of the store. *Courtesy of the author.*

Although not a resort, Williams Store deserves further mention here, as it was a popular spot for summer visitors and local residents alike. Carol Senecal's father, Joseph Manell, first became caretaker at Williams Store in 1920, when it was still operating. The store was accessible from Creek Road via a steep slate stairway. On the upper level there was an ice cream parlor where customers could sit on wrought-iron chairs to enjoy their ice cream. Carol owns several items from the ice cream parlor, including a glass cone holder and syrup bottles. On the lake level, boaters could purchase gasoline and the store had a boat rental business. After being caretaker for many years, Joseph Manell purchased the building from Flora Williams in the 1960s. He renovated it for use as the family's summer cottage. Today Paul and Marsha Fontaine own the cottage and have restored it to its present appearance.

After Jeremiah Durick passed away in 1954, the former Glenwood cottage was neglected and broken into several times during the 1970s. In 1972, Bernard Stockwell became caretaker for Jeremiah's daughter, Catherine Durick Lull. Catherine and her husband, Bob, traveled from their home in Shelburne on Memorial Day and stayed in the cottage until September. Bernard Stockwell had fond memories of working for the Lull family. He did the usual maintenance chores and observed them enjoying the same pleasures as the previous generation. One day in 1978, while he was repairing the roof of the Williams Store, he observed "children vacationing from Long Island who ran off the Williams dock and landed in deep water without being able to swim. When I heard screams for help, I jumped off the roof to bring the children to shore," Bernard recalled in an interview.

When the senior Lulls no longer spent time at the cottage, their children used it occasionally. It remained in the Durick/Lull family for over eighty years, until it was sold to Mr. and Mrs. Thomas Doran in 2000. Thomas Doran remembered in an interview:

> When the cottage was purchased in 2000, the building had been vacant for some time and the condition of the inside was in a poor state of affairs. The building had been on the market for several years so the family responded favorably to my offer. I had to tear down the plaster and gut the interior before modernizing the inside. This included removing bat manure from years of being vacant.

Today, the cottage has been restored, and when a new septic system was being put in, the present and past collided. Numerous dishes and bottles were removed as the excavation reached the cellar of the old Glenwood Hotel.

This recent photo shows the former Williams Store, the Winsport guesthouse, Doran cottage and the vacant lot where the Glenwood once stood. *Courtesy of the author.*

A metal reservoir located seventy-five feet behind the Glenwood lot and a metal pipe that ran to the former wash house can still be seen. A motorized pump drew water from the lake into the reservoir, and it was gravity-fed into the wash house. Other articles from the Glenwood in Tommy Doran's collection are a butter dish and some pictures showing guests relaxing on the veranda and sailing in front of the hotel.

All the buildings in the photograph above are now private dwellings whose appearances do not hint at their former role in the history of the lake. Bernard Stockwell recalls his father's stories describing how the steamboats traveled up the creek every day to the Glenwood, the Prospect House and other spots along the lake. If a hotel had passengers awaiting transport, a white sheet would be hung out on the front porch. The steamer blew its horn to announce its arrival. The steamboats, like the early hotels, are long gone from living memory.

The Cedar Grove Hotel

Before the Cedar Grove Hotel was built in 1898, Mark Bixby purchased land north of Prospect Point and for years ran a boat livery and boarded sportsmen who came to fish on Lake Bomoseen. This site was one of the early picnic resorts and had a grove of cedar trees from which it got its name. When Edward Dunn purchased the property, he continued to run the boat livery. On July 4, 1898, he opened the newly constructed four-story Cedar Grove Hotel. During more than twenty years of ownership, Dunn acquired Cedar Grove Farm, which provided fresh vegetables and milk for hotel guests and added two cottages nearby to accommodate additional visitors. After World War I, in 1919 Mr. Dunn retired and sold the Cedar Grove to John J. Quinlan. Quinlan expanded the hotel with a twenty-six-room annex that included a spacious social hall for the guests' entertainment.

Before purchasing the Cedar Grove Hotel, John J. Quinlan, who was from Saratoga, New York, had experience managing the Hotel Ausable Chasm in the Adirondacks and had been steward of the Ormond Beach Hotel during winters in Florida. At the Ormond Beach Hotel, he met his wife, Elizabeth Farrell, a telephone operator there. While working at the Ormond Beach Hotel, Mr. Quinlan employed many African American workers who later traveled north to work at the Cedar Grove in the summer months.

At one point during the 1920s and 1930s, all three west shore hotels employed black workers who traveled north from Florida to work during the summer season. "At the Cedar Grove, Dave Handy was the head chef, Rozena took care of baked goods and Carmen prepared the salads," said John Quinlan's daughter, Loyola Kratz Rhyne. The majority of the staff came from the surrounding region, however, and lived at the "Tin House," where male and female employees stayed on separate floors—women on the top floor and the men on the ground floor.

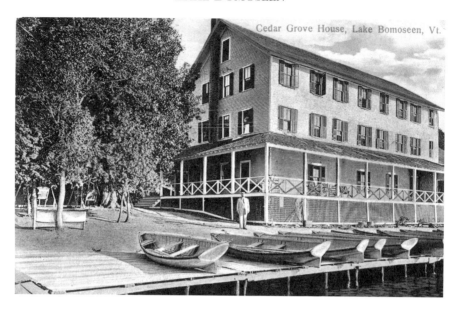

Cedar Grove House, Lake Bomoseen, Vt.

The Cedar Grove Hotel offered boats for guests' use. *Courtesy of the author.*

The summer of 1920 was the first season for John J. Quinlan as owner. By that time, the trolley spur coming up from Castleton Corners had been discontinued. Many guests during the 1920s came by train up the Hudson River from metropolitan New York City to Whitehall, New York, and then to the Castleton Depot, where they would be met by a horse and wagon and taken to the hotel.

Loyola Kratz Rhyne recalls:

The hotel rooms were not luxurious by modern standards; at first only a wash basin and pitcher of water were provided, but later sinks were installed in each room. However, guests shared one bathroom per floor, each with a tub and shower. The furniture consisted of a four-poster wooden bed, a bureau with a marble slab top and a tilt mirror.

The hotel provided various types of entertainment for guests in the social hall. Dances, movies, bingo, inside horse racing games and, later, "one-armed bandit" slot machines all amused the visitors. Guests often gathered around the fireplace to socialize or sing along as someone played the grand piano shown in the postcard view. If guests wished for other entertainment, across the street was Mahar's Tom Thumb miniature golf course and the Bomoseen Golfland was farther down the road, as well as a nine-hole golf

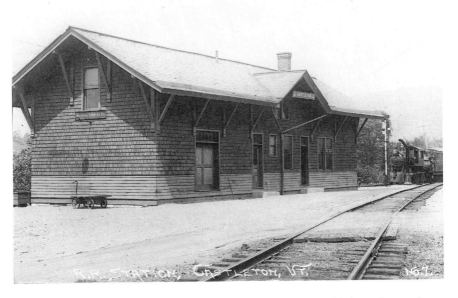

Resort visitors arrived at the Castleton Depot, now a coffee shop and bakery. *Courtesy of Castleton Historical Society.*

course. Those who enjoyed horseback riding went to Parker's stables, where a horse could be hired for one dollar an hour for a leisurely ride along the east shore of the lake. Guests who preferred to relax quietly could sit in the Cedar Grove and watch others boating or swimming. Tennis, shuffleboard and pitch putt golf were available as well. If guests wanted a change of pace from hotel food, nearby Calvi's Grill served a variety of toasted sandwiches, including hot dogs and hamburgers. For souvenirs or gag gifts, visitors could patronize Duclos's stand. Families with young children who stayed at the hotel or cottages often planned day outings such as hiking, and the hotel kitchen prepared box lunches for them. Hiking up to Wallace Ledge, with its spectacular view of the lake, was especially popular. As many as fifty guests, guided by Farrell or Tessie Quinlan, would make the climb and enjoy a picnic and cool drink at the foot of the falls. The *Fair Haven Era* reported that on July 25, 1940, following one such hike, the Cedar Grove team defeated the Trakenseen men in softball.

At the height of business during the 1920s and 1930s, famous people came to Lake Bomoseen, drawn by such attractions as the Gibson Crystal

Cedar Grove had a spacious social hall in which guests could enjoy a variety of activities. *Courtesy of the author.*

Guests could sunbathe on Cedar Grove's terrace or enjoy the swimming area. *Courtesy of Loyola Kratz Rhyne.*

The Story of Vermont's Largest Little-Known Lake

Ballroom. Members of the exclusive literary group, the Algonquin Round Table, were guests of literary critic Alexander Woollcott on Neshobe Island, but they sometimes liked to get off the island for entertainment. Semiformal dances with local bands playing were held at Cedar Grove's social hall, and celebrities—including Harpo Marx, a member of the Algonquin Round Table—attended and danced with "many of the local ladies. He [Marx] also signed autographs and came to dinner as a guest of the Quinlan family," as described in *Beautiful Lake Bomoseen*. Loyola Kratz Rhyne recalled that her father once had to ask Harpo to leave, however, when his behavior became objectionable.

At the nearby Casino, the former Gibson's Crystal Ballroom, people could dance to big bands such as Jimmy Dorsey, Gene Krupa or Vaughn Monroe for only one dollar admission. The structure, which measured 106 feet by 96 feet, was built down the hill from the former dance pavilion at the old Bomoseen trolley park. By the early 1950s, the Casino/Crystal Ballroom had been a popular dance spot for over thirty years. Entertainers such as Louis Armstrong continued to make appearances.

Before World War II, many of the waiters and waitresses returned season after season and guests typically stayed for two weeks every year, although some came for the whole summer. This helped create a family-like atmosphere. Each day, a new menu was printed with green ink on white paper. Waitresses served breakfast starting at 7:00 a.m., dressed in their perky checkered outfits. Lunch was served from noon until 1:00 p.m., and waitresses wore a different uniform. For the evening meal, waitresses dressed more formally still, as did the guests. Loyola Kratz Rhyne recalls that her mother, Betty Quinlan, owned fourteen different gowns so she could wear a different one each night in her capacity as an unofficial hostess. This practice changed by the 1940s, but even then guests were expected to be more dressed up for dinner.

Waitressing involved more than just serving meals three times a day. Waitresses were up by 6:00 a.m. to help with food preparation, such as cutting up fruit and vegetables, and they were also responsible for keeping their assigned areas of the dining room swept and clean. In the years before World War II, the local staff took pride in keeping their guests happy and eager to return year after year. Many guests did exactly that. A July 11, 1940 article in the *Fair Haven Era* stated that "many guests at Cedar Grove might be classed as residential—they return each season. For example, Mr. Joseph Costley of Jersey City is spending his twenty-first consecutive summer at this popular hostelry, while Barney Sheridan and Al Benedict returned this year for their eleventh summer outing at the lake."

John J. Quinlan was a very busy man during the 1920s. In addition to owning and running the Cedar Grove, he was also part owner of the Prospect House with J. Howard Hart and president of the Trakenseen Hotel Company. Mr. Quinlan and Mr. Hart donated land to build a Roman Catholic church on the east shore near the Prospect House for summer guests. It was called Our Lady of the Lake, and the building still stands today, although it is no longer used as a church. John J. Quinlan was responsible for the accounting at the Cedar Grove and Prospect House and also handled advertising, with ads placed in New York City and Albany, New York newspapers. His ads typically promoted reasonable rates for the Cedar Grove and claimed that the Prospect House was the most popular vacation spot in Vermont.

Mr. Quinlan's interests stretched beyond Lake Bomoseen, as he was also co-owner of the Dunmore Hotel on Lake Dunmore and for a time was the vice-president of the New England Hotel Owners Association. His family members were also deeply involved in the hotel business. His brother, Leo P. Quinlan, and Leo's wife, Mary Bird Quinlan, managed the Cedar Grove Hotel and were part owners of the Trakenseen. John J. Quinlan's children grew up learning about hotel management. Before college, his son Tom worked as a dishwasher and groundskeeper, and daughter Betty was a clerk.

This 1960s brochure shows boating and swimming at Cedar Grove. *Courtesy of Loyola Kratz Rhyne.*

Tom took over management after his father's death in 1937. At one point, Tom Quinlan owned the Loomarwick Hotel in Connecticut. His brother, Farrell J. Quinlan, was owner of the Indian Cave Lodge on Lake Sunapee in New Hampshire. After the Second World War, John Quinlan Jr., better known as Jack, helped his mother Elizabeth run the Cedar Grove Hotel, along with his sister, Betty. Betty became vice-president of the Cedar Grove Corporation and was the hotel's accountant.

During the 1960s, the Lakeside Cocktail Lounge and Grille was built next to the hotel. John J. Quinlan Jr. provided dock facilities for the growing number of lake residents who liked to come by boat. The lounge was immediately popular, as it was one of the few places that provided cocktails and nightly entertainment. An advertisement in the August 9, 1963 *Resorter* stated, "With the introduction of facilities for boats, nightly entertainment, and the superb grille menu, the Lakeside Lounge is becoming one of the most popular night spots on Lake Bomoseen, and the kind of attraction that Lake Bomoseen has long needed: good food, good drink, and good entertainment."

In the summer of 1963, the Cedar Grove Hotel celebrated its fortieth anniversary under the continuous ownership of the Quinlan family. During the 1960s, the Quinlans sold off some property and eventually sold the hotel

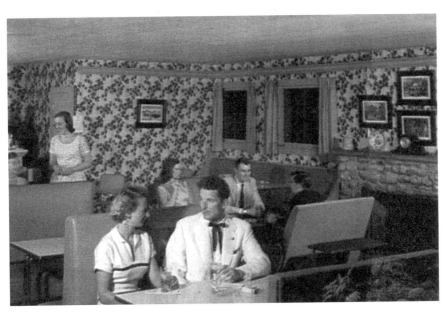

The cocktail lounge was added during the 1960s to attract additional patrons. *Courtesy of Loyola Kratz Rhyne.*

The paved area in this recent photo is where the shuffleboard court was located, and the Cedar Grove Hotel was located near the trees. *Courtesy of the author.*

itself to David Reiser in 1971. The hotel continued to operate until it was torn down in 1974. Some cottages remained but are now private dwellings. The shuffleboard court now is used to provide parking space along busy Route 30.

The Grand View Hotel and Sherman's Beach

In 1908, the Grand View Farmhouse was advertised in the D&H Railroad's summer destination booklet, *A Summer Paradise*. It was located four miles from the Castleton station on a peninsula at the entrance to the outlet of Lake Bomoseen. "The rooms are large and airy; fresh farm products, accommodates twenty, terms $7.00 per week, and open all year."

By the time Frank Sherman purchased the fifty-two-room hotel in 1921, it had been sitting idle for at least three years. The property, consisting of the main hotel, cottage, boathouse, barn and icehouse, was in a sad state of disrepair. In an interview, Jay Magwire remembered that Frank Sherman's wife, Hazel, often commented, "Half the cottages around Lake Bomoseen have windows taken from the Grand View Hotel."

Sherman tore down what was left of the hotel's main building and combined the cottage and bathhouse into one building. The icehouse on the south side of the peninsula was used by the Shermans for many more years. The barn caught fire one winter night during the 1930s when a man, seeking shelter, started a small fire to keep warm.

From the early 1930s until 1956, Sherman's Beach was open to the public. Hazel Sherman charged ten cents to swim and twenty-five cents to rent a locker and basket in the bathhouse, which was a portion of the old hotel. One end of the bathhouse had a small store in which Hazel sold candy and ice cream to beachgoers, boaters and nearby residents.

During the winter months, all of the major resorts on Lake Bomoseen cut their own ice to store for the summer season. The ice blocks were packed in layers of sawdust for insulation, and they kept quite well inside the icehouse. Frank Sherman and other family members typically cut ice in the area above Sherman's Point, just south of Williams Store. By the late 1930s, he had rigged up a machine to cut the ice, making the job less labor intensive.

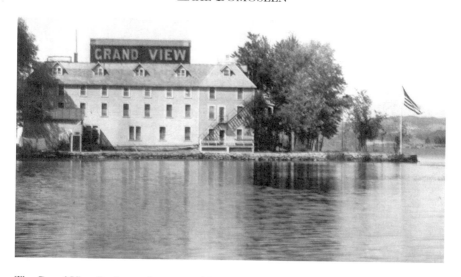

The Grand View lived up to its name, with one of the finest views on the lake. *Courtesy of the author.*

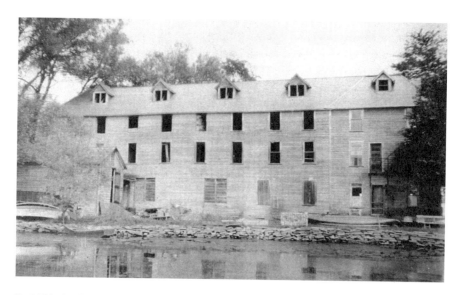

By 1921, the Grand View had fallen into disrepair and was missing windows. *Courtesy of Jay Magwire.*

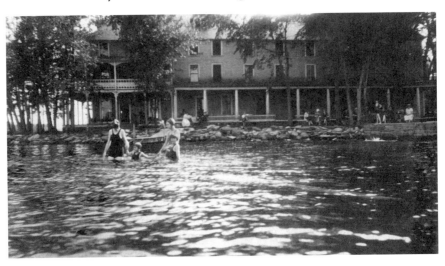

Swimmers enjoyed the Grand View's fine swimming area, as shown in this circa 1920s photo. *Courtesy of Jay Magwire.*

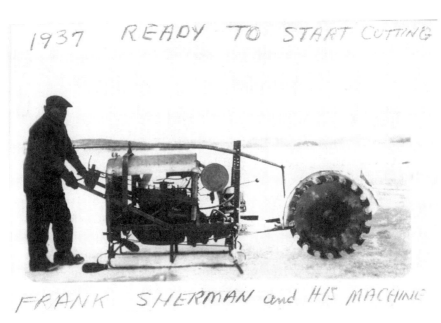

By 1939, Frank Sherman had invented his own ice-cutting machine. *Courtesy of Jay Magwire.*

Although not strictly a resort in the usual sense, a summer youth camp was established near Sherman's Beach by a Methodist minister, F.S. Cooley, in 1934. It began modestly, with area boys pitching tents in Mr. Ransom's pasture. During the next two summers, the number of campers expanded to thirty boys. By the third season, they gathered at MacRae's Orchard, opposite Sherman's Beach, where they had morning devotions and received swimming lessons at MacRae Beach. They also erected a carved wooden totem pole about nine feet in height in Mr. Ransom's pasture. Each boy paid a weekly fee of three dollars, and donations of vegetables, ice and milk were solicited from area families. Scholarships were provided for those unable to pay the fee.

Before the start of the 1938 summer season, the area clergymen who ran the camp convinced community leaders to form the Fair Haven Community Camp, Inc., a nonprofit organization aimed at building and maintaining a camp for both boys and girls. The site was moved to the west shore of Lake Bomoseen on an abandoned farm property overlooking the lake above Sherman's Beach. The new camp was made possible by the Allen Bank, which deeded the three hundred acres to the organization with the stipulation that the land be used solely for the education of young people. It was named O-Wan-Ya-Ka, meaning "vision," perhaps in reference to the breathtaking view, but certainly the camp's founders possessed vision for its future as well. An article in the April 1999 *Castleton Newsletter* described the scene: "According to Mike Barsalow, when one stood on the hill and looked across the lake, there was a pine tree that looked like an Indian with a war bonnet."

The *Fair Haven Era* newspaper reported that during the 1939 season Camp O-Wan-Ya-Ka had qualified leaders who took youths on canoe trips, led hikes on the Long Trail and taught rifle practice and archery. Mr. and Mrs. Raymond Magwire served as directors for the second season, and Howard Magwire was a counselor and assistant director of aquatic activities.

Today, the Edward F. Kehoe Conservation Camp, named after a longtime director of the Vermont Fish and Wildlife Department, is open to boys and girls between twelve and sixteen years old for weeklong sessions. Its outdoor program includes firearm safety instruction, canoeing, swimming, water safety, bluebird box construction, orienteering and wetlands study and exploration. Thanks to the vision of one clergyman over seventy years earlier, several generations of the area's young people have attended the camp, developing lifelong skills and an appreciation for nature.

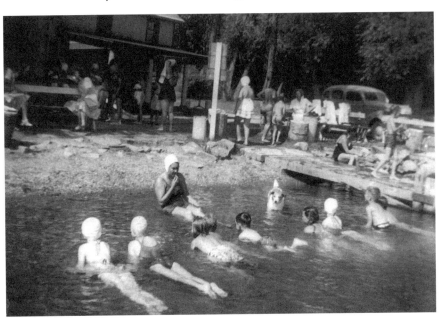

Nethelia Magwire gave swimming lessons for Camp O-Wan-Ya-Ka at Sherman's Beach, 1938. *Courtesy of Jay Magwire.*

In 1948, with many years of experience as camp directors, Nethelia and Raymond Magwire ran Camp Sherman for girls. The full six-week camp season cost $200, and the girls received swim lessons and sailing instruction, went on canoe trips and took field trips to such places as Fort Ticonderoga, the White Mountains, the Long Trail and local points of interest.

Sherman's Point has seen many changes during the three generations that the Shermans and Magwires have lived there. The salvage of the Grand View Hotel in the 1920s, the popularity of Sherman's Beach in the 1930s to mid-1950s, the development of the conservation camp on the hill and the changing water level of Lake Bomoseen are examples. In the spring of 1938, Sherman's Point almost disappeared under high water, but by fall the point was left high and dry, so much so that boaters could not pass through the channel to the outlet. The photograph on the next page illustrates the flood level in 1938.

During the early morning hours of Wednesday, February 9, 1972, fire broke out and "destroyed what was a renovated portion of the old Grand View hotel...[Jay] Magwire's grandfather converted what was left of a fifty-two room hostelry into a summer house," reported the *Rutland Daily Herald* in 1962. By the time firefighters arrived at 1:20 a.m., the four walls had

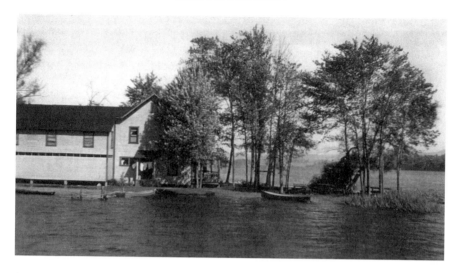

Sherman's Point had problems with spring flooding in 1938. *Courtesy of Jay Magwire.*

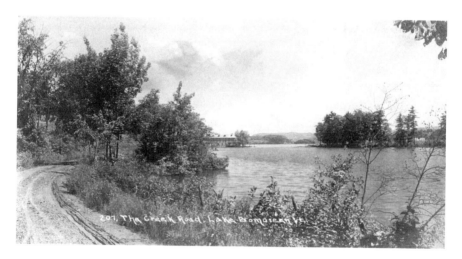

The last leg of the journey to the Grand View Hotel on Creek Road, circa early 1900s, when it was unpaved. *Courtesy of Linda Splatt.*

collapsed. The newspaper article went on to note that Fire Chief Jerome M. Grady had passed the house between 11:00 p.m. and 11:15 p.m. Tuesday night and had seen nothing unusual. Earlier Tuesday evening, firemen were called to put out a fire at an abandoned barn and slate mill off Scotch Hill Road, and firefighters later speculated that the slate mill fire was possibly

a decoy for the more major fire at the old Grand View Hotel site. Both buildings had had the power shut off, making it unlikely that the fires were accidental.

Jay and Carolyn Magwire built a new home on the site in June 1972, and they lived here until 2008. The Magwires protected the shoreline from seasonal flooding by building a breakwater, and they planted a cedar hedge to control erosion and provide some privacy. Sherman's Beach is no longer a public beach, but the current owners, the Wethereds, rent out dock space on their waterfront. As in past years, boaters going from the outlet into the lake still must be concerned about the shallow water; those unfamiliar with the channel often find themselves scraping the bottom if they drift too close to shore.

Today, all remnants of the old Grand View Hotel have disappeared, but Sherman's Point can rightly claim one of the best views on the lake. One can imagine the thrill that summer visitors must have had when making the last leg of their journey to the Grand View for the first time. The sight of the grand hotel, with its spacious porches providing a panoramic view of the lake, must have been impressive.

Hydeville's Bomoseen Inn and the Harbor Store

The hotel pictured on the next page has had several incarnations during its more than a century of existence on Lake Bomoseen. The September 10, 1903 edition of the *Fair Haven Era* reported that "Daniel E. O'Brien of Fair Haven purchased of the H.C. Gleason estate, the site of the Hyde Hotel, just north of the Bolger Slate Mill and will at once have a hotel erected upon it to cost $6,000." The first photograph shows the newly completed hotel, without any landscaping or trees around it. The second photo shows the hotel just a few years later.

In its early years, the O'Brien's Hotel prospered due to its location between the Hydeville Railroad Station and the steamboat dock at the end of the creek. The hotel's appearance was improved with awnings over the windows and the addition of young shade trees. In 1913, about ten years after building the hotel, Daniel O'Brien applied for a first-class liquor license. The following year, a modern electric sign illuminated the southeast corner of the hotel.

Daniel O' Brien was interested in attracting guests to his establishment. In May 1914, the *Fair Haven Era* reported that O'Brien "received 500,000 perch and pike fingerlings and distributed them in Lake Bomoseen." He intended to stock more fish before the end of the season and may have hoped to provide better fishing to attract more sportsmen, and he always wanted to ensure a good supply for future fish dinners at his hotel.

Before widespread ownership of cars, people traveled by train to the Hydeville Station. Then they walked over to the steamboat pier, where steamers *A.B. Cook* and, later, *Arthur B. Cook*, delivered passengers to the Glenwood Hotel, the Lake House, the Prospect House and other destinations on the lake.

In 1916, Joseph Gibson purchased O'Brien's Hotel for $6,500 and renamed it Gibson's Hotel on Lake Bomoseen. It was known by this name

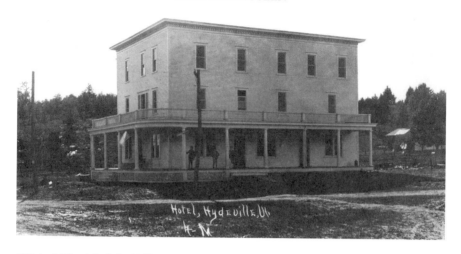

O'Brien's Hotel, built in 1903, was located near the steamboat pier in Hydeville. *Courtesy of Linda Splatt.*

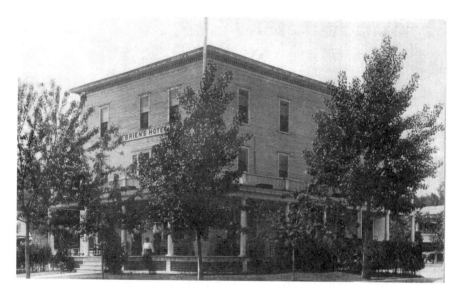

A few years later, O'Brien's Hotel, shown here with improvements such as awnings and landscaping, hoped to attract sportsmen. *Courtesy of Linda Splatt.*

The Story of Vermont's Largest Little-Known Lake

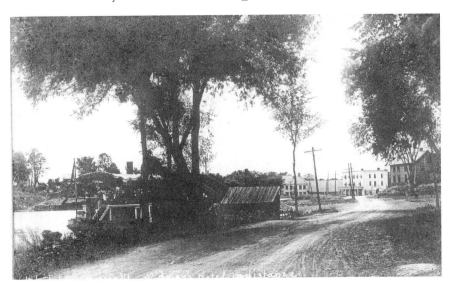

The steamboat pier was convenient to the Hydeville Station and O'Brien's Hotel. *Courtesy of Robert Woodard.*

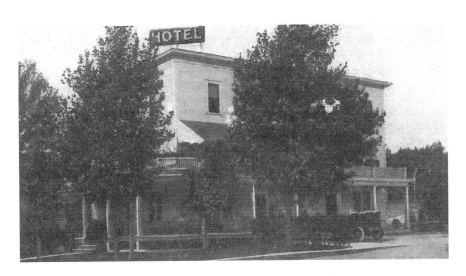

In 1916, O'Brien's Hotel was renamed Gibson's Hotel by its new owner, Joseph Gibson. *Courtesy of John Tolin.*

through the mid-1940s. John Tolin, aged eighty-two at the time of an interview in June 2008, has many memories of the Gibson's Hotel era. After his parents' marriage broke up in 1925, John went to live with his grandfather, Joseph Gibson, and lived upstairs in the hotel for eighteen years. For much of the time that he lived there, John recalls that the main gathering place for customers was the poolroom next to the bar downstairs. Local farmers and slate workers from the nearby quarries or finishing shops came in after work for a drink and to play pool. John first learned to play by standing on a box or stool so he could see over the edge of the pool table. As he remarked, "What else could you do in the winter around there in the 1920s?" Some of the players, including his grandfather, took it very seriously and did not lose gracefully.

Joe Gibson kept several horses and a sleigh in a barn behind the hotel, now the site of the present-day Harbor View Store. John's Uncle Paul raised mink in an outbuilding on the west side of the hotel. He made good money at it until his business was wiped out when the mink were unknowingly fed horse meat tainted with medication that killed them.

John Tolin describes his upbringing as strict. "When I did something wrong, I got it!" But he also said that his grandfather saw that he lacked for nothing, and Joe Gibson was generous to his family. After he opened the Crystal Ballroom near the Prospect House on the east shore of the lake in 1921, he built cottages nearby for his three brothers. The one that belonged to his brother Ray still stands today as the Pines, next to the Trak-In parking lot.

Joe Gibson was strict about his new dance pavilion, the Crystal Ballroom. Gentlemen were required to wear a jacket and tie for admittance to the dance floor. During the Prohibition era, from the 1920s through the 1930s, liquor was not sold at the Crystal Ballroom, at least not officially, but Joe Gibson did sell bootleg liquor. One day, his mother hastily took John Tolin out of the hotel to a neighbor's, just ahead of federal agents seeking illegal moonshine. In spite of a thorough search of the premises, the feds could not discover the Gibsons' illegal cache of bottles, which was concealed within a metal table used for meat cutting.

During John Tolin's boyhood years at Gibson's Hotel, there were storage barns and boathouses all along the creek. An icehouse stored the ice cut during the winter. Water was pumped from the creek to a third-story tank to provide water pressure. Cars parked on the side closest to the creek, and the Gibsons often watched local kids swimming just above the dam. They dove off two piers on either side. This could become dangerous, however, if the dam was opened to lower the lake, as the current became quite swift.

The Story of Vermont's Largest Little-Known Lake

As a youth, John Tolin attended the Hydeville School. One of his first jobs was putting up flyers to advertise the Crystal Ballroom. During the summer, he also worked as a bellhop for several establishments, including the Trakenseen and Cedar Grove Hotels. He worked briefly at the Hyde Manor in Sudbury but found the location too isolated. With the eighteen-dollars-per-month salary, plus tips, he was able to purchase his suits and other clothing for school. Like many other young men of the time, he enjoyed some of the Lake Bomoseen attractions, such as Parker's Riding Stable.

As time went on John's Uncle Paul "Put" Gibson lived at the hotel and took over more and more of the daily operations. Joe Gibson was getting older and was afflicted with "shaking hands." By 1940, Joe Gibson sold the Crystal Ballroom to Joe Pellerin. Shortly after, World War II began and John Tolin entered service to his country as a marine. When he finally returned home, his grandfather died in 1946, and the hotel was sold to Leo Foley and his brother. John Tolin helped his family move out of the Gibson's Hotel to Blissville, where they still reside today.

When brothers Francis and Leo Foley purchased Hotel Gibson in June 1946, they renamed it the Hydeville Hotel. Francis Foley put up the money to buy and upgrade the hotel, and later that fall Leo and his wife and daughter Patricia moved in. Patricia attended Castleton Normal School but also helped her mother in the kitchen and waited tables. Eventually, local girls were hired for these jobs. The majority of the local staff proved to be very reliable, with one notable exception. A female bartender loved the beer as much as her customers did; not only did she join them for a drink, but she also dispensed free beer to the patrons. Leo Foley's daughter Patricia Richards recalled, "She almost drank us out of house and home!"

Leo Foley seems to have been a rather reluctant barkeeper. He did not drink himself and did not like being a party to patrons becoming drunk at his bar. He would have much preferred the Hydeville Hotel to be known for its good food and homey atmosphere. Unfortunately, this wish was never fully realized, and the bar at the hotel remained a popular place for locals to meet friends for drinks. The bar was a good moneymaker, so Leo Foley remained in his role as barkeeper. For the most part, the patrons were orderly and did not drink to excess, but on Saturday nights there were a few hardcore drinkers whom Leo did not deem to be safe behind the wheel. So he took the responsibility on himself to drive them home after he had closed up at midnight. He used to look around church on a Sunday morning to see if he'd recognize any patrons from the night before a little worse for the wear! Unlike many similar establishments, Leo Foley strove to keep it a respectable place and patrons were not urged to drink more than they should to make

more money. At that time, it was not the gathering place for college students it later became. When the Hydeville Hotel installed one of the first television sets in the area, this drew many customers, especially to watch special events or sports.

In spite of the fact that Leo was a good cook, the bar remained more profitable than the dining room. There was no set menu; Leo would cook to order whatever locals or hotel guests wanted. The portions were generous and the price was very reasonable, perhaps too much so. Leo catered dinners for many area service clubs, and for ten dollars he served T-bone steaks, mashed or baked potatoes, vegetables, rolls, desserts and coffee. Many of the meal patrons during the summer brought their children to or from the summer camps around the lake. The dining room was patronized by locals as well, particularly around the holidays. The Hydeville Hotel was famous for its pies, especially peach pie in the summertime. Patricia Richards said that her father made the best apple pie in Vermont, but her mother would complain that she peeled all the apples and he got all the credit!

The hotel had three stories, with the kitchen, dining room and bar on the ground floor and guest bedrooms on the second and third floors. There were thirteen bedrooms and guests shared bathroom facilities. The Foleys lived on the second floor, and when the hotel was busy, they also shared a bathroom with guests. The main change that Leo Foley had made to the hotel was refurbishing the first-floor dining room. He enlarged it and papered the walls in dark blue paper with white flowers. The chairs and tables were painted white. A smaller, private dining room adjoined the main one. A striking feature in the barroom was the antique mahogany bar.

Most guests were seasonal, except for old Owen Owens, who boarded there year-round and did odd jobs for the Foleys. For many years a group of businessmen from Worcester, Massachusetts, came every winter to ice fish on Lake Bomoseen. Patricia Richards remembered, "The leader of the pack was a dentist who drove up in a classy new Caddy...He was often accompanied by a Catholic priest wearing 'civvies.' My father apologized for the language at the bar, but the priest assured him he could take it and that Dad must not spoil the fun of others." The group was also known for their generous tips.

Business dropped off during the World War II era. Although it picked up again once the war was over, the hotel was never at capacity again. The Foleys decided that the hotel needed a catchy slogan to attract customers. Leo's daughter Patricia recalled that someone suggested, "The Hideout Inn, Hydeville," but her father vetoed that as being too Mafia-like. They erected a sign on Route 4A that read, "Delightful Loitering at the Hydeville Inn."

The Story of Vermont's Largest Little-Known Lake

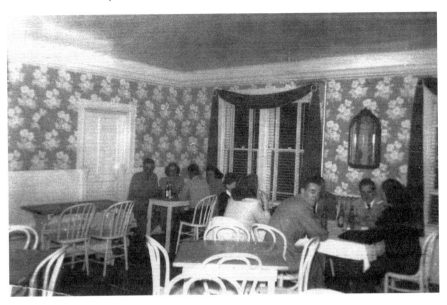

The Hydeville Hotel, owned by Francis and Leo Foley, had an attractive dining room and good food. *Courtesy of Patricia Richards.*

In 1950, in spite of efforts to make a go of it, the Foleys had to sell the hotel after being in business for only about four years. Francis Foley could no longer provide the funds to keep it going. The hotel and property were sold once more, this time to Art and Irene Fredette in April 1950. It then passed to Ed Carpinski. In 1962, Mr. and Mrs. John Mulligan purchased the Hydeville Hotel.

At first, Mr. Mulligan only came up to Vermont from New Jersey on weekends, so Mrs. Mulligan and her Aunt Sally ran the hotel. Mrs. Steele, a former employee, was kept on to run the bar, but she and Aunt Sally had differing opinions on how to manage the bar and hotel. Mr. Mulligan was able to effect a compromise between the two women. During the Mulligans' first five years of ownership, the bar only seated sixteen people. In 1967, the bar was extensively renovated, making it the longest bar in Vermont. Customers had demanded that the bar remain open during renovations and on occasion helped with the work. One day, while replacing some wiring, electricians stumbled over a trapdoor, possibly dating from the Prohibition era when illegal liquor was smuggled in.

Like their predecessor Leo Foley, the Mulligans wanted to develop the restaurant facet of the business. They built a barbecue pit in the kitchen

and promoted steaks, pork chops and "the best hamburgers in town." The Mulligans' daughter, Kathleen, had the job of marinating the pork chops in beer to tenderize them and give them unique flavor. However, the Mulligans learned, as Leo had, that running the kitchen was not very profitable. They sold fishing and hunting licenses and began to cater to sportsmen who wanted a good breakfast or dinner. The Inn also served holiday meals; a St. Patrick's Day buffet became a specialty, with corned beef, cabbage and green beer, accompanied by live Irish music. Kathleen remembers that it was the local color that made working at the Inn enjoyable. People from all walks of life came in, and some stayed nearly all day.

The Mulligans added a new slate-covered T-shaped bar, and Mrs. Mulligan laid the last piece of slate, engraved with her name and the date, 1967. A new era began, with a dance floor in one corner and popular bands such as the Starlighters performing on Saturday nights. On Wednesday nights, the college crowd lined up for "Dog Night," when ten-cent beers were offered. The Bomoseen Inn became part of the Castleton student tradition. Some students would meet friends and study or chat at tables, and others brought their visiting parents to see the longest bar in Vermont. John Mulligan, Ruth Steele and John's son-in-law, Roy Knapp, kept a watchful eye on the students' behavior. Mrs. Steele kept handy her "ra-rah stick" with which she threatened any rowdies.

The most famous college tradition connected with the Bomoseen Inn was known as "Walking the Dog." This rite of passage was for seniors just prior to commencement. The students would climb up on the 110-foot bar and walk from one end to the other. Seniors have now been walking the dog for over forty years, although today it is not quite as impressive, since the bar was shortened in 1993. The bar's unusual nickname, the Dog, is said to have come from an earlier owner who had a bulldog. This animal would whine and "talk" for food from customers who came to see the "Talking Dog." Eventually, the "talking" part was dropped and the bar was just referred to as the Dog.

The Mulligans sold the bar to Steve Brothers, and Curtis King has now owned it for the past twelve years. The six apartments upstairs are no longer rented out. The bar still is popular with students, but now Curtis King and his bouncer, Kelton Brooks, are the ones keeping an eye on the young people. In the September 26, 2007 issue of the college paper, the *Spartan*, writer Tony Trombetta commented, "The Dog is a refuge for stressed-out college kids who just want to let loose on Thirsty Thursdays in a safe environment." College students of drinking age now congregate there on Thursday nights for a glass of Natural Light draft for just fifty cents. Just as the previous bar

owners discovered, the local regulars are the bread and butter of the bar business. Local quarry or construction workers and businessmen stop in for drinks in the afternoon.

One such loyal local customer is Ralph Norton, who has been coming to the Hydeville Inn for over sixty years. At almost eighty-eight years of age, he still drives himself there almost every day; the main difference now is that he's more likely to order a soft drink than a draft beer. Bartender Mandy Wood commented, "He has probably come here for his entire adult life." He has observed many changes over the years that he has been a patron and recalls the establishment's heyday, when a dining room existed and it could boast the longest bar in Vermont.

Behind the hotel is a red outbuilding that once served as a stable for guests' horses. The Mulligans were advised to have it torn down because it was in poor shape, but they decided to renovate it. Upstairs they made an apartment for their daughter, Kathleen, who was relocating from New Jersey, and put in a beauty shop downstairs for her, called Red Barn Coiffures. The old barn boards were cleaned and stained, and the horse stalls were converted into beauty stations. It was in business for six years, and at one time Kathleen employed four girls. Kathleen's father used to kid her that the site was an old Indian burial ground; he had discovered several Native American artifacts, such as projectile points, during the renovation.

In the early 1960s, local contractor John Kenworthy transformed the building into a store. It has had several owners: Mr. Ruskin and Jim Rea in the 1970s, and Kevin and Laurie Knauer from 1980 to 2000. In the first few years of the twenty-first century, it has changed hands several more times: Jim LaDuc, Mary Doran and Stan Yablonski each owned it for brief periods. Mary Doran modernized the store in 2000 and gave it a new look and atmosphere, adding gift items, gourmet coffee, bakery goods, ice cream and sandwiches, in addition to newspapers and grocery staples. Mary Doran had grown up locally, part of a large family, and when home for a visit she discovered that the store was for sale. She was quoted in the October 19, 2000 *Fair Haven Promoter*, "If you want to see any of my seven brothers, just stop in between 6:30 and 7:00 in the morning, and join them for coffee."

The current owners, Dave and Pat Finlayson, continue the tradition of catering to both summer residents and locals. Their "Creemees," soft ice cream, are served from a window counter overlooking the dam at the end of the creek. Customers look forward to each new flavor of the week. Lake residents and visitors often arrive by boat to treat their families to Creemees on hot summer days. A sure sign of the season's end is when Dave closes the ice cream window each fall. However, the Harbor View General Store

Today, the Harbor View General Store is a popular stop for ice cream and necessities. *Courtesy of the author.*

is open year-round; although the summer seasonal visitors have left, local residents patronize the store for its good coffee, baked goods, sandwiches, staples and newspapers.

Cottage Communities of the Early Twentieth Century

Today, the vast majority of dwellings on Lake Bomoseen are privately owned summer or year-round homes. But during the early part of the last century, only a few cottages existed that were not part of the hotel and resort complexes. The first cottage community was Point of Pines, started in 1905, followed by the Avalon Beach cottages in 1910. The third community, Crystal Haven, was built a decade or two later, between 1925 and 1930. Information on Avalon Beach has been included in the chapter about the Ellis Park Hotel, as those cottages were built on the original hotel grounds.

The point of land on the west shore, with its majestic pine trees, was owned by Marceleau Maynard until May 2, 1892, when it was sold to Charles W. Tennant for $500. Mr. Tennant died before subdividing the property, but his heirs began selling lots around 1902. By the end of 1924, the lots and common ground became part of the Point of Pines Cottage Community, Inc. Twenty-eight colony members purchased shares in this corporation. The colony comprised 13 acres of land between Creek Road and Point of Pines Road. The first twelve cottages were built around a 2.5-acre common area between 1907 and 1917. The common area and beachfront were open to all the families in the colony. The remaining homes were built along the shoreline in the late teens through 1920s. At its peak, the colony had twenty-eight homes, but over the years two burned and one was rebuilt. Later, one homeowner disassociated from the colony, which left twenty-six families.

In 1907, Charles Leonard, June Cashman's grandfather, built one of the first cottages at Point of Pines. She recalls her grandfather saying that carpenters walked from Fair Haven every day to build the house. It has remained in the family for four generations; the Cashmans' three daughters now come with their families, as well as June's brother John and his family.

June Cashman has been coming to Point of Pines since infancy and has many happy memories of summers there. She recalled that the community

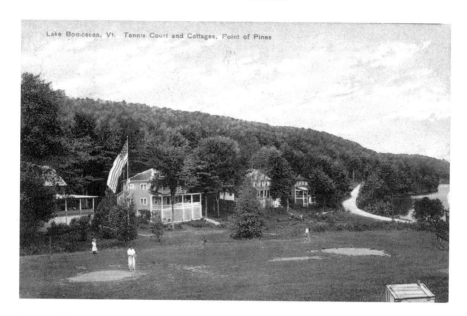

Point of Pines was the first cottage community at Lake Bomoseen, started in 1905; photograph circa 1912. *Courtesy of the author.*

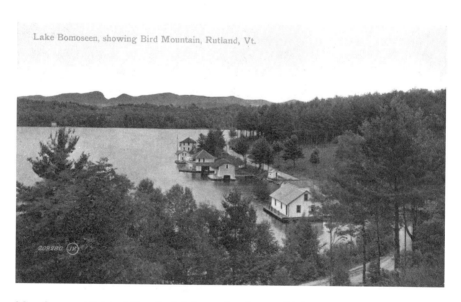

Many homes at Point of Pines had their own boathouses. Bird Mountain can be seen in the distance. Note the incorrect identification as Rutland. *Courtesy of the author.*

was like a summer resort during the 1930s and 1940s, with tennis, badminton courts and water skiing. Like many children around the lake, she took swimming lessons at age eight from Nethelia Magwire at Sherman's Beach. She recalls visiting the black bear that was kept in a cage at Neshobe Beach. As she grew up, she enjoyed listening to the dance music of famous bands like Gene Krupa, sitting in the parking lot at the Casino. June also attended the square dances held at the former MacRae apple barn on Drake Road. A trip to the "Red Barn," now the Harbor View General Store, has always been an enjoyable family activity. The Cashmans used to pull their grandchildren behind their boat on a homemade wake board, long before these became popular and commercially available.

June Cashman continues to be actively involved with the Point of Pines Association, serving on its board of directors. Each family pays yearly dues, and every summer the annual meeting is held at one of the cottages,

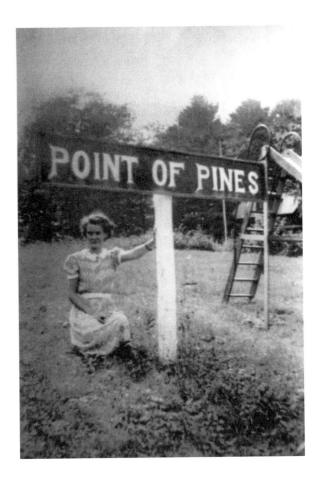

June Cashman posed next to the sign as a young girl in the 1930s. *Courtesy of June Cashman.*

starting at 10:00 a.m. with coffee and donuts served on the porch. Her father made the trip from Brooklyn, New York, every summer just to attend the annual meeting.

The summer season at Point of Pines officially begins on May 15, when the water supplied from nearby springs was turned on, and ended on October 15, when it was shut off for the winter. Many of the earlier homeowners had large families, and both children and adults looked forward to the simple pleasures of summer cottage life: swimming, boating, playing baseball on the common and fishing. At one point in the 1940s, there were so many summer residents using the waterfront that the association hired a lifeguard. Other outings might include playing miniature golf across the lake at Tom Thumb or Golfland or going dancing at Gibson's Crystal Ballroom during the 1930s. Families also could swim at Sherman's Beach and buy an ice cream cone at Williams Store on Creek Road. On Sunday mornings, most families went to church and spent the afternoon relaxing on their shady porches, possibly cheering on their favorite ballplayers during the Sunday afternoon baseball games. Like many of the people who stayed at the large hotels on the east shore, families usually came for the summer. The wives and children stayed at the lake while the husbands commuted to their jobs in Rutland or farther away. The women supervised the children and household and socialized with each other. They didn't need to go into town very often, as a milkman supplied the community with milk, and fresh bread, pies and pastries were delivered by Barsalow's Bakery in Fair Haven.

The architecture at Point of Pines represents early twentieth-century vernacular wood frame construction, using a combination of Queen Anne and Colonial Revival styles. The Queen Anne style typically featured a wide porch and an irregular roofline that provided many rooms with a lake view. The houses had clapboard siding, wood shingles and novelty trim, and they were built on the slope to catch cooling breezes. Most had storage areas on the ground level, concealed with lattice skirting.

Another establishment was located just south, between the Point of Pines community and the Glenwood Hotel. Burdett's boardinghouse provided accommodations during the first decade of the twentieth century. According to a former owner, Butch Cote, the Downtown Athletic Club of Chicago, associated with the Chicago Bears football team, stayed at Burdett's during their training camp. The present owners, Mr. and Mrs. James Lewis, have maintained a unique feature of the dwelling—seven doors that have the numbers three, seven and fifteen through nineteen on them, possibly corresponding to football jersey numbers. Since the post–World War II period, Burdett's has been a private home and has undergone several

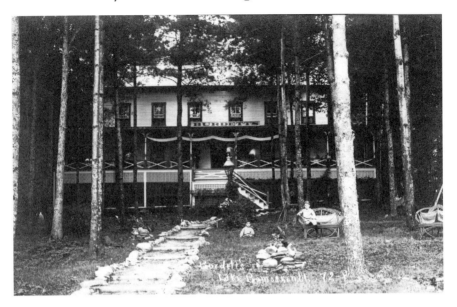

Burdett's guesthouse was just south of Point of Pines during the early 1900s. *Courtesy of the author.*

structural alterations, including enclosing the porch and removing trees to provide a better lake view.

A little farther north from Point of Pines, near the Green Dump, a group of local businessmen built the Fair Haven Country Club House in the early 1900s. This was not a country club in the sense of country clubs today, which are generally golf courses, but rather it was a place where these men and their families could come and enjoy the beauty of Lake Bomoseen.

In the late 1800s, the Town of Castleton purchased 380 acres from Endearing Johnson and Ardon Eaton for $5,000. At least 286 acres of that parcel along Route 30 became the Castleton Town Farm, or Poor Farm as it was sometimes called. Eventually, the town sold off the Town Farm land for building lots, and the Crystal Haven cottage community was begun. The cottages, built between 1925 and the early 1930s, were constructed in four different styles: pyramid, shotgun, bungalow and Cape Cod. The pyramid style is easily identified by its pointed roof resembling a pyramid. There were five built in this style, with a square floor plan, and all but one are one-story dwellings.

The shotgun-style cottages were typically rectangular, usually three rooms long by one room wide. They were so named because it was said that one could open the front and rear doors and fire a shotgun through without

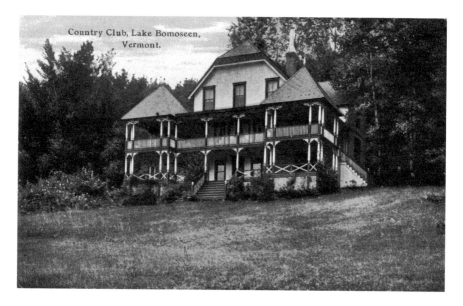

The Fair Haven Country Club was built by a group of businessmen, but it did not have a golf course. *Courtesy of the author.*

hitting anything. In reality, the design enabled cooling air circulation in the days before air conditioning. Both the pyramid and shotgun styles originated in the lowland areas of our country and can still be seen in the South today. There are three such cottages at Crystal Haven.

The third type of cottage at Crystal Haven was the bungalow. It was typically one or one and a half stories with a broad gable roof covering the screened porch. The floor plan was square or rectangular. The construction design used rafters or ridge beams that extended beyond the walls. The exterior was often shingled on the upper level with asphalt and had clapboard siding on the lower level. All three bungalows at Crystal Haven feature a fireplace. Many of the original cottages were built by employees of the Vermont Marble Company, who purchased lots along the lake from the Castleton Town Farm.

The bungalow belonging to George and Linda Jackson is one of the earliest in the community, begun in 1929 by George's grandfather. George tells an amusing story about his grandparents' acquisition of the property. His grandmother urged her husband to buy the adjoining lot just to the north, but he declined and only purchased the one lot. When it came time to build the cottage, he explained to his wife that they would have to situate it within so many feet from the adjoining lot. "Oh, don't worry about that," she told him. "I own that lot. And I own the two across the street, too!"

Unbeknownst to the rest of the family, she had bought the property, a smart and bold move, especially during those times. George's father worked all summer in 1930 on the cottage, as he was out of work.

Today the cottage is almost eighty years old, and the family has preserved much of its original appearance. Four generations of the Jackson family have enjoyed it as a summer home, and the Jacksons' children own an adjoining cottage as well. The photograph below shows how it appeared in 1930 without any trees, a simple basic cottage that was typical of the time. Over the years, the lakeside porch has been enlarged and screened in, and a deck was added. The house is not winterized and serves strictly as a summer retreat. George Jackson mentioned that the upstairs windows are unique to their cottage, as they originally came out of an old church. There are fewer and fewer of these old-style cottages or "camps" left around the lake, as more and more become year-round residences or are extensively remodeled.

The most common style cottage at Crystal Haven was the Cape Cod. There were six of these, and each featured a massive central chimney and a rectangular floor plan organized around the chimney. Most had two front rooms and two bedrooms. Mary Phalen Oczechowski's father, a worker at Vermont Marble, built their Cape Cod cottage between 1934 and 1936. During the summer, the cottage was often rented out, sometimes to members of the Quinlan family, who needed to free up rooms at the Cedar Grove Hotel during their busiest times. Unlike the Jacksons a few doors to

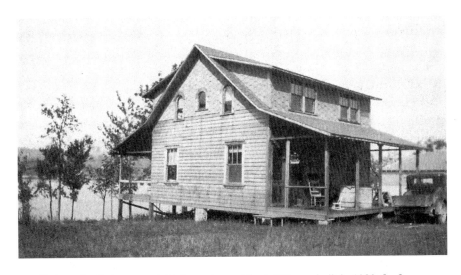

The Jackson family has owned this bungalow at Crystal Haven, built in 1930, for four generations. *Courtesy of George and Linda Jackson.*

This well-preserved cottage is an example of the Cape Cod style found at Crystal Haven. *Courtesy of Mary Phalen Oczechowski.*

the south, Mary's family came to the lake in the winter to ice fish or cross-country ski, since they lived only a few miles away in West Rutland. The original slate roof of Mary's cottage has held up for over seventy years. Like most other longtime residents around Lake Bomoseen, Mary has seen many changes and watched establishments such as the Casino and Uncle Charlie's Restaurant come and go or change hands over the years.

The northern end of the Crystal Haven property was originally owned by the Spooner family, who had a farm directly across the lake at Spooner Point. They sold the property to the Kelly family in 1938. The homeowners on the northern end were very sociable and joined together for various activities such as cocktail parties, horseshoes and softball and volleyball games. The residents on the southern end generally kept more to themselves and did not join in with the northern end. Some think this was due to the lack of a homeowners' association that might have united the two groups.

Besides Point of Pines, Crystal Haven and Avalon Beach historic districts, there are three others on Lake Bomoseen. Five cottages built in 1915 between Route 30 and the east shore of the lake feature Queen Anne– and Greek Revival–style architecture. Heading toward the southeastern end of Lake Bomoseen, north of Indian Point, is a community known as Little Rutland, so named due to the number of Rutland folks who built or purchased these

cottages. Most were constructed between 1910 and 1920. They typically have screened porches facing the lake, enclosed on the bottom with lattice skirting. Just to the south is the Green Bay Historic District. One of the oldest houses in the smaller Green Bay district dates from 1890. It has a gambrel roof and related outbuildings, including a boathouse. It is currently owned by George and Elizabeth Lamphere. In Chapter 15, mention is made of the Neshobe Beach cottage community, the last group of cottages to be added during the post–World War II period.

Today, many of the cottages from these early communities have been renovated, enlarged or modified several times. While most have been preserved by their owners, unfortunately, in spite of being located within a historic district and the uniqueness of their architecture, several have fallen into neglect or ruin.

Entertainment on the Lake, Part I

Gibson's Crystal Ballroom and the Casino

Many people mistakenly believe that Bomoseen Park dance pavilion and Gibson's Crystal Ballroom were one and the same. The last dances were held at Bomoseen Park in 1917, as the park closed before the 1918 season. The dance pavilion was removed to the Rutland Fairgrounds, where it was used for dances and later enclosed for exhibitions.

With the end of the "Great War," World War I, the country was eager to get back to normalcy, but the 1920s turned out to be anything but normal, compared to pre–World War I standards. Jazz music hit the scene, as did flappers with their bobbed hair and short skirts. During the era, the American public flocked to listen to jazz bands, bought dance records to play on their Victrolas at home and listened to popular bands on the new radios of the time. This interest in dancing and band performances created a market for the construction of open-air dance pavilions, such as the Crystal Ballroom.

In 1920, the Rutland Railway, Light and Power Company sold Bomoseen Park to the Lake Company, which in turn sold the property to Joseph and Georgianna Gibson. The Gibsons moved into the hotel next door, while Joseph Gibson cleared the land farther down the hill from the site of the old park pavilion. With help from contractor Fred Graves and his own sons, Gibson built a large 106- by 96-foot dance building. The new structure had floors constructed of hard maple lumber from British Columbia, brought first by train and then by truck to the site on Route 30 in the middle of the spring mud season. The new dance pavilion featured a stage for musicians on one end, and it had a large dance floor separated from spectators by railings on three sides. A sparkling revolving crystal ball was suspended from the center of the ballroom ceiling, giving the new facility its name, the Crystal Ballroom. It was the largest dance pavilion in Vermont.

On June 22, 1921, Gibson's Crystal Ballroom opened for business with its first dance. White's ten-piece sax jazz orchestra played for a crowd of about

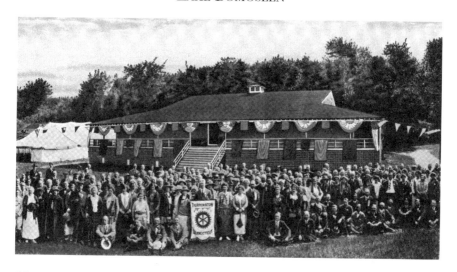

Gibson's Dance Pavilion was a popular spot for group outings, such as this Rotary Club gathering. *Courtesy of Roz Rogers.*

1,500 people, who were delighted with the magical atmosphere created by beautiful decorations. Colored streamers and bunting adorned the ceiling, and the crystal ball reflected the multicolored lights strung around the room. For this opening, patrons traveled by trolley and then took William Bull's "water wagon." Mr. Bull advertised that using his boat was the cleanest way of getting from the trolley to the largest and best dancing pavilion in New England, while enjoying a boat ride on the lake, all for twenty-five cents. This appears to have been one of the last seasons that this method of transportation was still available, since trolley service between Rutland and Fair Haven was eliminated by 1924. After that, more people owned cars and the roads were better.

At Gibson's Crystal Ballroom, semiformal attire was required—evening gowns for women and business suits and ties for men. No refreshments were served in the ballroom and liquor was not allowed inside. Showing up with liquor on one's breath was grounds for expulsion. Deputy sheriffs were on hand to enforce the peace and prevent any fights. However, sometimes enterprising bootleggers did brisk business in the parking lot, where people would sit in their cars to listen to the music. Many families brought blankets to sit on and walked over to the nearby concession stands that lined Route 30 for ice cream and hot dogs. Compared to today, that area of Route 30 was a beehive of activity, with local people and hotel guests alike flocking to dance or enjoy the music and patronize the concessions on a warm summer evening.

Admission to the dance floor was one dollar per couple, except for special events. The dances were held every Monday, Wednesday and Saturday evening

from 9:00 p.m. until midnight. During the first few seasons, the bands were mainly small local groups, but by the mid-1920s larger orchestras from farther away began to appear. In May 1925, Red Nip's orchestra from Boston played, and the following year the Border Nighthawks nine-piece orchestra performed. Prince Kavanaugh's eleven-piece orchestra returned for four seasons starting in May 1927. On opening night in 1929, a record nine hundred couples crowded the dance floor. Even after the stock market crash of 1929 and throughout the Great Depression of the 1930s, attendance at the Crystal Ballroom remained steady. Most of the people attending were local and came in their own cars.

Gibson's Crystal Ballroom was open from Memorial Day until Labor Day. After the summer season ended, the facility was rented out to groups such as the Rotary Club and Kiwanis Club, both of which held annual conventions there. Some of the conventions went on for a week and featured such activities as dances and clambakes. Clams, corn and chicken were steamed in a pit dug in the parking lot.

In 1932, the Gibsons added ten modern tourist cabins built in a semicircle across from the Trakenseen Hotel, hoping to attract more summer patrons. However, the end of Prohibition in the early 1930s brought a decline in attendance at Gibson's Crystal Ballroom. With alcoholic beverages readily available again, many people now preferred an establishment where they could get a drink *and* dance. Places such as the Hampton Restaurant across the state line in New York attracted such customers. In an attempt to counter this trend, the Crystal Ballroom sought big name bands, but it cost more for famous entertainers, so the Gibsons were no further ahead financially. The management tried a variety of special events, such as a ten-cent dance. On July 4, 1936, the Gibson Crystal Ballroom was decorated in patriotic colors and 650 couples danced to the music of Val Jean and his eleven-piece orchestra.

Throughout the 1930s, Gibson's Crystal Ballroom continued to bring in well-known bands and orchestras of the times. In 1933, Jimmy Farnham's ten-piece Jungle Club Orchestra from St. Petersburg, Florida, appeared. The Alabama Acres, "New England's greatest African American band," played several times. In 1938, Robert Shaw and the Aristocrats were featured, as well as Violet Smith and her Coquettes, billed as America's greatest all-girl band. In spite of this wide variety of talent offered, the Crystal Ballroom was struggling to stay afloat financially, so in 1938 the management instituted a twenty-five cent fee for those who wished to sit on the grounds.

The year 1939 saw the last season for Gibson's Crystal Ballroom. On March 30, 1940, Joseph Gibson sold the establishment to Joseph Pellerin, who changed the name to the Casino. Unlike today's use of the word "casino," gambling was never offered at the Casino on Lake Bomoseen, only

Announcing . . . the

GRAND OPENING

THURSDAY NITE, May 30th

—of—

THE CASINO

LAKE BOMOSEEN
(formerly GIBSON'S)

Featuring . . .

"AL" DONAHUE and HIS FAMOUS BAND

DIRECT FROM ROCKEFELLER CENTER

"Al" Donahue has one of the Finest Orchestras in America and is undoubtedly one of the BEST BAND ATTRACTIONS ever to play in Rutland County. The Band is augmented by some well-known vocalists.

Tickets $1.00 Plus tax

The Pavilion has been remodeled and a modern restaurant completed, enabling food to be served on the veranda.

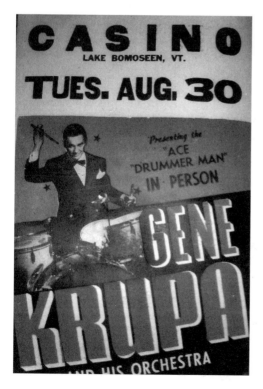

Above: Al Donahue's band was featured at the grand opening of the Casino on May 30, 1940. *Courtesy of Rutland Historical Society.*

Left: Gene Krupa performed at the Casino in the 1940s. *Courtesy of June and Harlan Cashman.*

entertainment. The new owner then leased the Casino to the Green Mountain Amusement Corporation, which brought in local bands, but occasionally famous big bands were engaged as well. No cover charge was required for the local groups; it was hoped that increased attendance would bring in enough profit from the food and drink purchases to make up for the lack of a cover charge. On May 30, 1940, the Casino had its gala grand opening, which featured the Al Donahue Orchestra, advertised as being direct from Rockefeller Center, New York. Admission was only one dollar. The Casino offered casual fare such as sandwiches, beer and nonalcoholic beverages.

During the 1940s, the Casino drew crowds with such celebrated bands and performers as Jimmy and Tommy Dorsey, Frank Sinatra, Fred MacMurray, Gene Krupa, Vaughn Monroe and Bob Hope.

The Casino also added a theatre, presenting in August 1941 *The Man Who Came to Dinner*, a Broadway hit written by Alexander Woollcott. On August 29, 1940, the *Fair Haven Era* reported that the Weston Players presented *Another Language*, an American comedy, as the concluding play of the season. During World War II, attendance at the Casino dropped off due to gasoline rationing and the war effort, but once the war was over, it was back in full swing again. During the 1945 season, the Casino Theatre presented plays every Monday evening and movies on Sunday nights. Local orchestras provided music for dance nights, with special bands appearing from time to time. The war-weary public was anxious to have a good time again, and the Casino fulfilled that wish. It is interesting to note that the attendees now tended to be younger than the patrons in the 1920s and 1930s, and they dressed more informally. While famous big name entertainers still appeared, the new venue of television was beginning to draw entertainers, who found it more lucrative than one-night gigs at the Casino at Lake Bomoseen, Vermont.

Judy Crowley, in an interview on July 6, 2006, recalled, "My dad brought two of us as high school students to experience the big band sound. Dad would sit in his vehicle while we went into the ballroom. [There were] big crowds. We mostly watched the dancers, and the bands always gave a good show." Two that she remembered were Tommy Dorsey and Louis Armstrong.

By the mid-1950s, the Casino's star was waning; the season began in early July instead of Memorial Day, and dances were reduced to one a week on Saturday nights. The big band era dance music was replaced with square dances. While some big names occasionally still came and drew good crowds in the 1950s—such as Louis Armstrong and his All-Stars, the Dorsey Brothers and the Grand Ole Opry—attendance in general was down. Competing night spots in the area served alcoholic drinks and played current hit music.

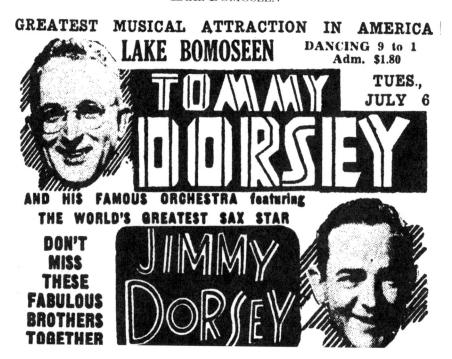

In 1954, people could dance to the Dorsey Brothers Band at the Casino. *Courtesy of Castleton State College.*

The Casino's owners realized by 1956 that they could no longer afford big name talent at their establishment, but they tried desperately to keep afloat and change with the times. They hired small local bands to play for the smaller crowds and often featured square dancing and polkas. In the early 1960s, an attempt was made to switch to rock and roll, but it was not successful because a popular DJ from an Albany radio station replaced live musicians. In 1962, record hops were held several times, but the handwriting was on the wall, and the Casino soon closed. The building was used for "crazy auctions," at which prices were actually bid down instead of up, but once the novelty wore off, those, too, petered out and the Casino closed its doors for the final time. Left neglected and vacant, the building's roof caved in due to heavy snow in 1967, and three years later a record snowfall brought the entire building down. It was a sad end to an era in which Lake Bomoseen was put on the map as a spot where big name entertainment could be enjoyed in a beautiful lakeside setting. Today, very little remains to mark the site of these two popular lake establishments, the Crystal Ballroom and the Casino. Few people alive today can recall the glory of the Crystal Ballroom firsthand, and even those who remember the Casino at its peak would be going back more than fifty years.

Entertainment on the Lake, Part II

Neshobe Beach and Crystal Beach

I n the early twentieth century, J.K. Pine ran a stock farm between Route 30 and the lake on which he raised sheep, horses and, later, Jersey cows. This property was purchased by Dr. Edward J. Quinn and Castleton town clerk Charles E. Brough, who in 1926 developed a large resort complex that included Pine Cliff Lodge and Annex, the nine-hole Bomoseen Country Club, Tucker's riding stables and Neshobe Beach. One of its brochures advertised, "This year choose the resort that has everything." This was not all advertising hyperbole, for the resort offered an astonishing variety of recreational activities: beach parties, golf tournaments, moonlight rides on the lake, tennis, shuffleboard, horseback riding, archery, croquet, badminton and so on. For those less athletically inclined, more sedate activities such as bridge, chess and billiards fit the bill.

On Friday, June 27, 1930, the *Fair Haven Era* reported the opening of Pine Cliff Lodge and Teahouse. The new annex, a converted horse barn on the property, would provide eight additional bedrooms, bringing the lodge's guest capacity to fifty. The new resort was soon considered one of the largest entertainment complexes in Vermont, and Neshobe Beach was billed as "Vermont's Coney Island." Although privately owned, Neshobe Beach was open to the public free of charge except for a fee to use the bathhouse. The large sandy beach and shallow slope of the lake bottom drew local families and hotel guests, and the parking lot was full on weekends. There were swings and a water slide for the children, and Prenevost's concession stand sold hot dogs, soft drinks and ice cream. Alcoholic beverages were not available, as Prenevost's did not have a liquor license. After church on Sunday during the 1930s and 1940s, working families would picnic in the shade and then go swimming at the best beach on Lake Bomoseen. Neshobe Beach was very popular, and it was not unusual to have eight hundred people on a hot Sunday afternoon.

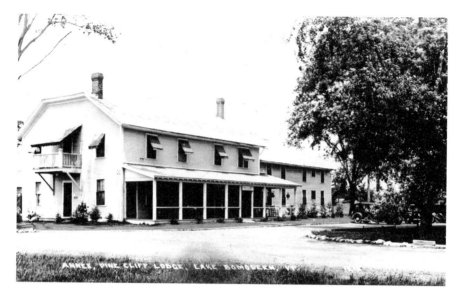

This former horse barn became the Pine Cliff Annex in 1930. *Courtesy of the author.*

Most working-class people of the time worked six days a week, with only Sundays available for leisure.

Coulman Westcott wrote in his *Fair Haven Promoter* article, "Bomoseen Recollections," that besides the swings and water slide "Neshobe always had a mini carnival going where you could throw baseballs at fake milk bottles or grab at floating ducks with lucky numbers painted on the bottom to win a doll or cheap ring to take home." Children especially enjoyed the small zoo, which included a tame bear, deer and monkeys. The black bear was contained within a chain-link fence, and he was a favorite attraction, as he loved to eat ice cream. The motorized swings and other attractions were run by Shorty Little, a "character of many trades, who drove a red oil truck on rainy days and during the winter."

In 1928, the Neshobe Beach management hired Frank D'Amico as a lifeguard and swimming instructor for the season. According to a news article in the *Fair Haven Promoter* on July 19, 1928, Mr. D'Amico had saved about 240 lives in his career. The paper urged readers to take advantage of this opportunity for the free course of twelve swim lessons.

The postcard opposite was sent in July 1931 to London, England, from one sister to another. She wrote, "Just a card from this place. We are here for a Sunday school picnic." Events such as this were common in the 1930s. The writer also commented that her companion, a good swimmer, was in the water.

The Story of Vermont's Largest Little-Known Lake

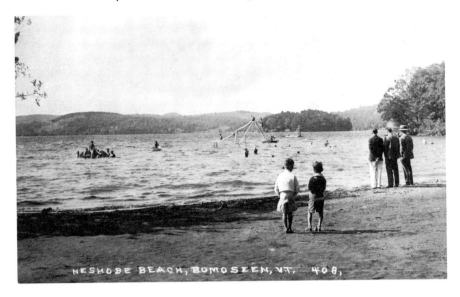

Neshobe Beach featured the nicest swimming area on the lake. This 1931 photo shows the water slide in the background. *Courtesy of the author.*

The Danceland pavilion had been added by the developers, Quinn and Brough, so local patrons and hotel guests could choose between Neshobe Beach and the Crystal Ballroom to listen to the music or dance to the swing bands of the era. To encourage attendance, admission was set at thirty-five cents for gentleman and fifteen cents for ladies. During the early 1930s, dances were held at the pavilion three nights a week, with music provided by local bands, such as the Fair Haven Band. Parking was free except on Sundays, when attendance was largest.

Quinn and Brough also built the Bomoseen Country Club in 1926. It was open to the public, with special rates for guests at Pine Cliff Lodge. During the 1930s, the par-thirty-six, eighteen-hole course extended from Drake Road to the southern half of the present-day nine-hole golf course, beginning and ending at Pine Cliff Lodge. In 1936, Coulman Westcott caddied for Harpo Marx. He recalled:

> *Counter to his movie image, he was very voluble and would swear in Hebrew when he made a poor shot (often). The caddy fee was thirty-five cents for 18 holes. Harpo paid me thirty-five cents with a nickel Coke as a tip. His companion was a bosomy former Miss Vermont Milkmaid, who played a better game of golf than he did.*

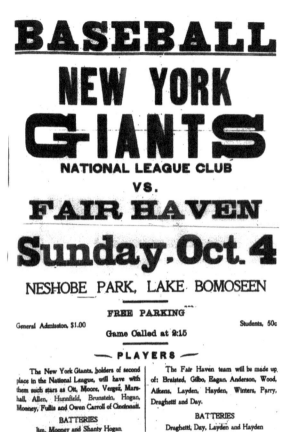

BASEBALL
NEW YORK
GIANTS
NATIONAL LEAGUE CLUB
VS.
FAIR HAVEN
Sunday. Oct. 4

NESHOBE PARK, LAKE BOMOSEEN

FREE PARKING

General Admission, $1.00 Students, 50c

Game Called at 2:15

— PLAYERS —

The New York Giants, holders of second place in the National League, will have with them such stars as Ott, Moore, Vergez, Marshall, Allen, Hunnfield, Brunstein, Hogan, Mooney, Fullis and Owen Carroll of Cincinnati.

BATTERIES

Jim. Mooney and Shanty Hogan.

The Fair Haven team will be made up of: Braisted, Gilbo, Eagan, Anderson, Wood, Aikens, Layden, Hayden, Winters, Parry, Draghetti and Day.

BATTERIES

Draghetti, Day, Layden and Hayden

As shown in the advertisement, the local team played the New York Giants on October 4, 1931. *Courtesy of Castleton State College.*

Besides golf, baseball was a very popular sport at the Pine Cliff Lodge/Neshobe Beach resort. A baseball field was built on the south side of the road leading to the beach, and Neshobe Field hosted both amateur and semiprofessional baseball teams. After the baseball games were over, boxing events were sometimes held at the field, but baseball was the big draw. During the 1930s, games between visiting semipro teams and local baseball teams were advertised in the *Fair Haven Era*. In August 1931, the Fair Haven team defeated the New York Colored Cubs, 6–3, and beat the Brooklyn Royal Giants after ten innings, 10–9. Following these two victories, the Fair Haven team was scheduled for a doubleheader against Chappie Johnson's Colored Stars and won. Baseball fans could watch the doubleheader for the same price as a single game. The team traveled to the Malone, New York fair to play a team from Carthage a week later. In October, the Fair Haven team hosted the New York Giants, the National League's second-place team, including Hall of Fame player Mel Ott. Five thousand fans attended this

game, Vermont's greatest sports event of 1931. The home team ended the season with twenty wins to seven losses.

During the next season, the Neshobe Indians played a varied roster of teams, including one from Amsterdam, New York, the Mohawk Colored Giants, and the Brooklyn Royal Colored Giants. When noting the team names, it should be pointed out that this was the era before integrated baseball teams. The Neshobe team had some good talent, such as Bob Cooney, formerly with the St. Louis Browns. Many of the visiting teams returned to play at Neshobe Field a second time in the season. One of the more unusual community teams was called the House of David. The House of David was a large religious community based in Benton Harbor, Michigan. On July 1, 1932, the *Fair Haven Era* reported, "This unique House of David team, besides the fact they never shave, have one other eccentricity—they are vegetarians. It looks like a bad day for butchers and barbers, but the baseball fans are in for real entertainment." The House of David team trained in Avon Park, Florida, every March, and they handled themselves quite favorably against such teams as the New York Yankees and the world champions, the St. Louis Cardinals. The House of David defeated the Neshobe team in a tightly played game, winning 6–5, and returned for a doubleheader later in the month. Besides baseball, Neshobe Beach often promoted boxing events before the baseball games. On Sunday, July 23, 1933, Bill Wood's Boxing Boys presented three bouts of three rounds each.

Beginning in 1923 and continuing for at least seven or eight years, there was a camp for boys on the east shore of Lake Bomoseen near Neshobe Beach, called Ne-Sho-Be. Three men from Albany ran the camp, which was in session from after July 4 until the end of August, for a cost of $250. The campers' day began with morning calisthenics and a dip in the lake. After breakfast, the boys' bungalows were inspected and then a wide variety of outdoor activities was offered. The campers were instructed in American Red Cross lifesaving and also were taught water safety and the proper use of the diving tower erected on a float in the lake. The boys were allowed to use the neighboring golf course and riding stable, with special rates.

During World War II, attendance at Neshobe Beach declined, as it had at other area resorts, due to gasoline rationing. People from far away didn't want the inconvenience of using public transportation, and local people saved their gas for necessities. On June 1, 1945, Pine Cliff Lodge was closed and the land was leased to Ralph Bove, Harry Franzoni and Paul Quinn for $2,500. Two years later, Mr. Franzoni purchased much of the property and turned it over to the Walla Walla Country Club. For Dr. Quinn, who was getting on in years, it was a good business move, but from then on Neshobe

COTTAGES AT LAKE BOMOSEEN COUNTRY CLUB --
LAKE BOMOSEEN, VERMONT B153
"WHERE THE GREEN MOUNTAINS MEET BEAUTIFUL WATERS"

Cottage community at Neshobe Beach, also called Walla Walla Country Club, post–World War II. *Courtesy of Castleton Historical Society.*

Beach was never open to the public again. It was used exclusively by the residents of the Neshobe summer cottage community.

Today, the former Walla Walla cottages still flank Neshobe Beach. Many have undergone remodeling by the individual owners over the years. The community retains the charm of its early years, and the residents enjoy one of the best swimming areas on the lake.

Miniature golf was very popular in the 1950s, and Lake Bomoseen could boast two such golf courses, both on Route 30. Tom Thumb was located near the hotels, and the Bomoseen Golfland was, and still is, just north of Drake Road. The Tom Thumb Miniature Golf Course had been in business for twenty-six seasons by 1954; besides providing a challenging course, it also served pizza, hot dogs, hamburgers and ice cream to patrons. Bomoseen Golfland was well lit so people could play at night, and it also had a double-decker driving range. In an article in the *Fair Haven Promoter*, columnist "Twig" Canfield wrote, "The double decks of the driving range were filled as the real golfers worked seriously on their game on the bottom deck. Up top the younger generation had their fun at a less serious game called Knock'em and Dock'em."

During the 1950s, a large one-story addition was built just north of the old Pine Cliff Lodge as a guest dining room. It was used mostly for special events such as wedding receptions. The Poremski family, owners of the Edgewater complex, bought it in 1975 and operated it as La Lago Lounge, a

nightclub and restaurant with Italian American cuisine. It only lasted a year, and several years later it was reopened as the Trak II Restaurant.

The story of Crystal Beach, the Castleton town beach still in use today, begins with Martin Kelly, a Hydeville storekeeper. When his business fell off after a slate workers' strike, Mr. Kelly sold out in 1913 and was hired by the Castleton selectmen as overseer of the town farm, also known as the Poor Farm. It was located on the corner of Route 30 and North Road. He moved his family to a large house with no electricity near Pencil Mill School. They took in summer guests, and Mr. Kelly, along with the poor farmworkers, grew potatoes in a field south of the house that Mrs. Kelly called the Crystal Beach House.

By 1922, Kelly began to notice increasing numbers of people taking a shortcut through the potato field to reach a swimming spot on the lake. These trespassers often trampled on and ruined the young potato plants. Mr. Kelly decided to make the best of this situation and converted the potato field into a public beach. He christened it "Crystal Beach," after the shimmering rocks in nearby Wallace Ledge. The old potato barn was reinvented as a concession stand and bathhouse with sixteen changing stalls. His daughter, Mary Kelly, sold hot dogs, candy, soft drinks and five-cent ice cream cones,

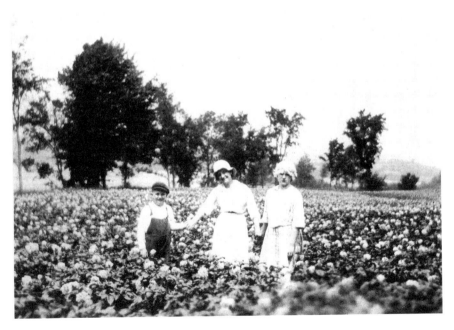

The potato field at the Castleton Poor Farm became Crystal Beach. *Courtesy of Jan Kelly.*

and unlike Neshobe Beach, 5 percent "near beer" could also be purchased. Mary Kelly also rented lockers and even bathing suits to beachgoers for twenty-five to fifty cents. She would wash the bathing suits out between customers and drape them over the nearby cemetery fence to dry. Mary Kelly later taught school until she married Jeremiah Grady, for whom the Float Bridge was named.

On warm summer weekends, the parking lot and picnic tables were full and a Victrola provided the crowd with popular tunes of the time. The town selectmen quickly realized that their former Poor Farm potato field was a gold mine and could be a moneymaker for the town, so they leased the concession rights to Mr. Kelly for $1,850, and he continued to run it for fifteen more years. In 1929, a water wheel was built, believed to be the only one of its kind in New England. Later a fifty-foot-long water chute was added.

Many people today enjoy the French fries and hot dogs at Roxie's stand on Route 4A near Castleton Corners, but few probably realize that this longtime establishment had its roots at Crystal Beach. In 1939, Earl Wilson started a snack bar and amusement concession at Crystal Beach, called "Wil-Sonia." Families brought their own picnic lunches or bought food from the snack bar. Among the rides were a Ferris wheel and a train

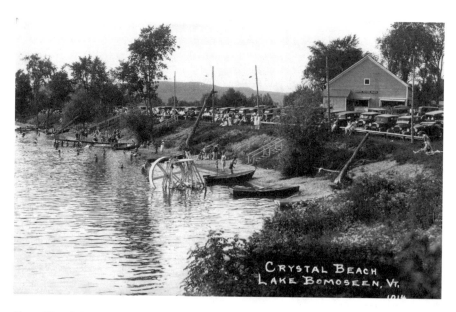

Crystal Beach had a water wheel but not much beach area in its early days. *Courtesy of the author.*

pulled by a small engine. In 1957, Sandi Rivers's grandparents took over ownership, and the snack bar now known as Roxie's has been in that family for over fifty years, although it has not been connected with Crystal Beach for many years. It is interesting to note the scope and variety of amusements available to summer visitors and local residents that existed in the past, compared to relatively few today.

In its early years, the use of Crystal Beach had not been restricted to town residents. But in 1969, after much debate about its future, it was decided to make the beach a taxpayer-supported facility and to charge a fee to nonresidents. Over the next few years, improvements were made, including a playground, landscaping, better picnic facilities and the replacement of the old concession stand. The beach and swimming area were graded and enriched with loads of sand. The early photograph above shows how the beach appeared prior to the modern improvements. The lake bank dropped sharply, and Judy Crowley recalled that if one wished to sunbathe on the beach, it had to be done nearly vertically!

Crystal Beach has hosted summer recreation programs, including Red Cross swimming lessons, countless family and organization picnics and various other events. The fee policy has varied, but at the present Castleton taxpayers can obtain a free season sticker; others must pay for a sticker or a daily entrance fee. After eighty-five years, it remains one of only two public beaches on the lake, the other being the Vermont State Park and campground on the west shore.

Conclusion

As the end of the first decade of the twenty-first century approaches, much has changed on Lake Bomoseen since the first resorts began over one hundred years ago. The grand hotels and modest boardinghouses have given way to private homes and cottages in which some people stay all summer and others for only a few weeks now and then. More and more of the old camps are being torn down and replaced with much larger homes or are remodeled so extensively that little can be detected of the original appearance. There seems to be a trend to more year-round residences as well. In my travels and interviews with people around the lake, it has been

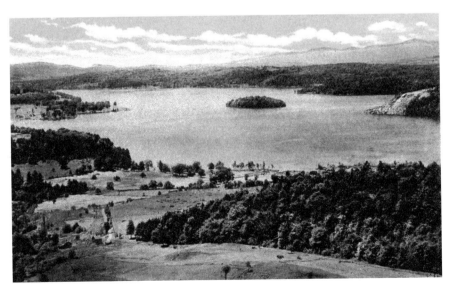

This turn-of-the-twentieth-century postcard view from Wallace Ledge shows much more area cleared for farming than today. *Courtesy of the author.*

wonderful to glimpse a few of the old camps that have been kept up much as they were eighty years ago. They are a vanishing breed.

The lake remains a popular destination for boating, swimming and fishing, but unlike years gone by, there are relatively few commercial establishments and amusements. People travel by car to places of interest in the area, and they generally own their own boats or rent them at local marinas. Not only has the style of recreation changed, but the land use has changed as well. The postcard in this section shows the view from Wallace Ledge, high above the lake, as it was one hundred years ago, with much of the land cleared for agriculture. Today that same view shows the land filled in with forest.

In 1954, the Lake Bomoseen Association was formed by residents of the lake. This organization has tackled such problems as lake pollution, the spread of Eurasian milfoil, boater safety and improvements to roads to the camps around the lake, all with the cooperation of state and local government. The ongoing efforts of the association and various governmental agencies will hopefully ensure that Lake Bomoseen will remain a pristine place to swim and boat for generations to come.

Bibliography

Beautiful Lake Bomoseen. Edited by Holman D. Jordan Jr. and written by history students at Castleton State College. Castleton, VT: Castleton State College, 1999.

Canfield, Twig. "Jimmy Done It." *Fair Haven Promoter*, August 27, 1998.

Cassedy, Marcella. *History of the Trolley Car*. On tape, read by Martha Langdon Towers. Castleton Historical Society Archives.

Castleton Historical Society. *Castleton Scenes of Yesterday*. Castleton, VT: Castleton Historical Society, 1975.

Currier, John M. "An Account of the Celebration of the Fourth of July, 1881, at Mason's Point, Lake Bomoseen." Rutland, VT: Rutland County Historical Society, 1881. Castleton Historical Society Archives.

Delaware & Hudson Railroad. "A Summer Paradise." Summer destination booklet, 1908.

"Edward F. Kehoe Conservation Camp." *Castleton Newsletter*, April 1999. Castleton Historical Society Archives.

Ellis Park Hotel on Lake Bomoseen. Promotional brochure, 1893. Castleton Historical Society Archives.

Fair Haven Era. "Captain E.C. Cook Held Up," August 31, 1911.

———. "Daniel O'Brien of Fair Haven Purchased Site for Hotel," September 10, 1903.

———. "Dramatic Stars Visit Woollcott at Lake Bomoseen," August 1, 1940.

———. "Glenwood, the New Hotel Erected on West Side of Lake Bomoseen," July 3, 1896.

———. "Guests Number 3000 at Wedding of Miss Stella Adams Ellis and Walter E. Snow," September 7, 1916.

———. "Many Former Guests Return to Cedar Grove," July 11, 1940.

———. "Stellar Attractions at Neshobe, Sunday, Indians to Play Bearded House of David Nine," July 1, 1932.

———. "Story of the Theft," December 21, 1911.

———. "Sudden Death of Hotel Man, William C. Mound," August 31, 1911.

———. "Weston Players present Another Language, an American Comedy," August 29, 1940.

Fair Haven Promoter. "Harbor Store is Open," October 19, 2000.

———. "It Happened Over Thirty Years Ago," January 30, 1997.

"The Float Bridge Reminiscences." *Castleton Newsletter*, July 2000. Castleton Historical Society Archives.

Jordan, Holman D., Jr. "Coon's Store: The Coon Family and Other Enterprises." Unpublished. Castleton, VT: Castleton Historical Society, 1981.

Marx, Harpo. "Buckety-Buckety into the Lake." *Vermont Life* (1961).

Patricia Richards, letter to author, May 10, 2008.

Poultney Journal. "Ellis Park Hotel in Ashes," March 9, 1894.

———. "H.B. Ellis at His Best—A Well Appointed Hotel," July 27, 1891.

———. "The Hop Given at the Prospect House Last Friday," July 31, 1891.

———. "Lake Bomoseen Is to Become Famous as a Summer Resort," August 28, 1891.

———. "The New Ellis Park Hotel Was Formally Opened," June 21, 1892.

———. "New Hotel Called the Del Monte House," July 17, 1891.

———. "Professor Van Arnum Master of Ceremonies at Ellis Park Hotel," September 2, 1892.

Resorter. "Lakeside Lounge at Cedar Grove Hotel," August 9, 1963.

Rutland Daily Herald. "6000 at Bomoseen, Immense Crowd Spends Day at the Park," July 27, 1894.

Rutland Herald. "Summer Hotel Burned, Hotel Glenwood Destroyed in Morning Fire," September 18, 1912.

Spaulding, Albert C. "Five Cents to Everywhere: A Chronicle of Green Mountain Trolleys." *Vermont Life* (Spring 1964).

Spencer, George D. *Lake Bomoseen: Its Early History, Conveyances, Fishing, Hunting, Resorts, Islands—Their Names.* Poultney, VT: Journal Job Printing Office, 1882.

Storm, John. "Castleton, Fair Haven Fires Work of Arsonist." *Rutland Daily Herald*, February 10, 1972.

Trombetta, Tony. "The Institution known as the Dog." *Castleton State College Spartan*, September 26, 2007.

Westcott, Coulman. "Bomoseen Recollections." *Fair Haven Promoter*, July 20, 1995.

Interviews

June Cashman, July 23, 2008.
Judy Crowley, July 6, 2006.
Polly Johnson Dolber, September 20, 2006.
Thomas Doran, September 28, 2006.
Ralph "Rex" Hayes, October 19, 2006.
Anna Guyette Hewitt, August 15, 2006.
George Jackson, July 2008.
Jay Magwire, September 9, 2006.
Loyola Kratz Rhyne, July 11, 2006.
Roz Rogers, July 26, 2006.
Bernard Stockwell, October 6, 2006.
Martha Langdon Towers, August 23, 2006.

Index

A

Acorn Lodge 44
Algonquin Round Table 34, 42, 103
Allen Bank 110
Armstrong, Louis 103, 139
Arthur B. Cook (steamer) 65, 82, 91, 115
Avalon Beach 81, 87, 125, 132

B

Baker, Charles and Harriet 75
Ballard, Charles K. 49, 51
Barker, A.W. and Jane 31, 32, 34
Barrett
 Earl and Marie 51, 53
 John A. 81, 82
Bird, Amos 17
Bishop, Harvey 29
Bixby's livery 30, 99
Blodgett, William 17
Bomoseen Bombers 24
Bomoseen Golfland 79, 100, 128, 146
Bomoseen Post Office 49
Bomoseen Trolley Park 49, 103
Booth, Enos 34
boxing 144, 145
Brooklyn Royal Giants 144
Brough, Charles 141, 143
Brown, Davene and Jerry 42
Bull, William 39, 136
Burdett's boardinghouse 128

C

Callahan, John and Missy Allen 28
Calvi's Grill 101
Camp Sherman 111
Canfield, Twig 146
Cashman, June and Harland 125, 127
Casino 103, 127, 132, 137, 139, 140
Castleton 17, 24, 33, 61, 65, 67, 69,
 81, 107, 129, 141, 147
Cedar Grove Hotel 13, 25, 30, 53, 63,
 72, 79, 99, 103, 104, 119, 131
Celebration Rock 32
Champlain, Samuel de 16
Chandler, Merritt and Midge 41
chert 15
Chowder Island 31
Coffee's Picnic House 29, 91
Cook, Captain C.E. 92
Cooley, F.S. 110
Coon's Store 16, 49
Copeland, Robert Morris 19
Cote, Butch 128
Creek Road 28, 96, 125, 128
croquet 36, 37, 42, 72, 84, 141
Crowley, Judy 139, 149
Crystal Beach 15, 55, 91, 147, 148,
 149
Crystal Haven 125, 129, 130, 131, 132
Currier, Dr. John M. 31, 33

D

Danceland pavilion 143
Delaware and Hudson Railroad
 (D&H) 67, 82, 107
Del Monte House 89
Doc Hyde's Place 28
Dolber, Polly Johnson 23, 25, 26, 28
Doran
 Joseph 81
 Mary 123
 Thomas 92, 96, 97
Dorsey Brothers 103, 139
Downtown Athletic Club of Chicago
 128
Duclos's stand 101
Durick, Jeremiah 94, 96
Dwyer, Horace 71

E

Eddie's Snack Bar 56
Edgewater Inn 56, 57, 60
electric water fountain 63, 68
Elliott, Roy 28
Ellis, Horace B. 71, 81, 82
Ellis, Stella Dyer 72
Ellis Park Hotel 13, 71, 81, 82, 84, 85,
 88, 125

F

Fair Haven Community Camp, Inc.
 110
Fair Haven Country Club 129
Finlayson, Dave and Pat 123
fishing 15, 21, 26, 28, 33, 39, 74, 84,
 115, 122, 128, 152
Float Bridge 21, 23, 24, 27, 28, 47,
 148
flooding 111, 113
Foley, Francis and Leo 119, 120, 121
Fontaine, Paul and Marsha 96
Frank's Place 56

G

Geeter, David M. 47

Gibson

Gibson, Joseph, Paul and Ray 115,
 118, 119, 135, 137
Gibson's Crystal Ballroom 27, 53,
 103, 128, 135, 137
Gibson's Hotel 27, 115, 118, 119
Glenwood Hotel 92, 96, 115, 128
Golden Jubilee 78
Goodwin, Theron 28
Grady
 Jeremiah 28, 148
 Jerome 112
 Jerry 78
 Mary 148
Grand View Hotel 107, 111, 113
Great Depression 26, 69, 137
Great Pond 17
Green Bay Historic District 133

H

Hampton Restaurant 137
Harbor View Store 118, 123, 127
Harry M. Bates (steamer) 89
Hart, Howard 75, 78, 104
Hayes, Ralph "Rex" 74, 75
Hazard, Harry "Hap" 44, 47
Hennessey, Helen and Joseph 41
Hewitt, Anna Guyette 53, 54, 55
Hope, Bob 139
House of David baseball team 145
Hyde, Russell and Rose 43
Hyde Hotel 115
Hydeville 13, 24, 28, 30, 32, 43, 82,
 91, 115, 119, 120, 147

I

ice cream parlor 43, 71, 94, 107, 123,
 128, 136, 141, 146, 147
ice cutting 118
ice fishing shanties 74
Indian Point 15, 16, 31, 132

J

Jackson, George and Linda 130, 131
Johnson
 Colonel Endearing 21, 24, 129

Daniel 21, 24
Hollis 21, 27, 28
Irene 21
Luthera 21, 25
Johnson, Loren R. 75

K

Kadien, Judge Thomas 75
Kaye, Sammy 56
Kehoe Conservation Camp 110
Kelly, Bryan 78, 79
Kelly, Martin 147
King, Curtis 122
Krupa, Gene 103, 127, 139

L

Lake Bomoseen Yacht Club 25, 65
Lake Champlain 15, 16, 17, 76
Lake House 25, 49, 51, 63, 93, 115
Lakeside Cocktail Lounge and Grille 105
La Lago Lounge 146
Lamphere, Elizabeth and George 133
Lee, Noah 17, 31
Leigh, Vivien 39
Lewis, James 128
Little Rutland 44, 132
Lull, Catherine and Bob 96
Lyman, Sue 81

M

MacIntyre, Donald and Sheila 44,
	45, 47
MacRae's Orchard 110
Magwire
	Carolyn 113
	Jay 107, 111, 113
	Nethelia 111, 127
	Raymond 110, 111
Manell, Joseph 96
Marx, Harpo 35, 37, 38, 55, 103, 143
Mason's Point 31, 32, 33
Menning, Irene and Jack 56, 57
Minniehaha 24
Monroe, Vaughn 103, 139
moonshine 118

Morris, Robert 19, 67
Mound, William C. 71, 89, 92
Mulligan
	John 121
	Kathleen 122

N

Naomi (steamer) 30, 32
Native Americans
	original settlement by 15, 16, 123
Ne-Sho-Be Boys Camp 145
Neshobe Beach 56, 127, 133, 141,
	142, 144, 145, 146, 148
Neshobe Indians 145
Neshobe Island 15, 31, 34, 42, 43, 56,
	76, 103
Neshobe Island Club 35, 41
New York Giants 144
Northrup, Ellis N. 93, 94

O

O-Wan-Ya-Ka Camp 110
O'Brien, Daniel E. 115
O'Brien's Hotel 115
Oczechowski, Mary Phalen 131
Olivier, Laurence 39
Ott, Mel 144
Our Lady of the Lake Chapel 78, 104

P

Page Point 47
Parker, Dorothy 38, 55
Parker, LeRoy H. 54
Parker's stable 101
Pine Cliff Lodge and Annex 141, 143,
	144, 145
Pine stock farm 141
Point of Pines Cottage Community
	89, 125, 127, 128, 129, 132
Pond family guesthouse 29
Poor Farm 129, 147, 148
Poremski, Red and Valerie 49, 56, 57,
	58, 60, 80, 146
Poultney 61, 65, 68, 92
Prenevost's Concession 141

Prohibition 76, 118, 121, 137
projectile points 15, 123
Prospect Bay 75, 80
Prospect House 13, 26, 53, 63, 71, 72, 74, 75, 76, 78, 79, 81, 89, 97, 104, 115, 118

Q

Quinlan family 51, 75, 78, 99, 101, 103, 104, 105, 131
Quinn, Dr. Edward J. 141, 145
Quinn, Paul 145

R

Rabbit Island 15, 43, 44, 45, 47
Red Barn 127
Richards, Patricia Foley 119, 120
Rogers, Roz 56, 57, 58, 59
Roxie's Stand 148, 149
Russell House 30
Rutland Fairgrounds 68, 135
Rutland Railway, Light and Power Company 49, 61, 65, 68, 69, 93, 135

S

Senecal, Carol 96
Shaw, Robert (Aristocrats) 137
Sherman, Frank and Hazel 107, 110, 111
Sherman's Beach 110, 111, 113, 127, 128
Sinatra, Frank 139
Spencer, G.D. 21, 28, 31-33
Spooner Point 132
St. Louis Cardinals 145
Steele, Ruth 122
Stockwell, Bernard 96, 97
Sugar Shack Cocktail Lounge 80

T

Taghkannuc House 32
Thoefel, John 75
Thomas, Colonel and Elizabeth 47
Thompson, Zodock 18

Ticonderoga 17, 111
Tolin, John 118, 119
Tom Thumb miniature golf 100, 128, 146
Towers, Martha Langdon 53, 54, 55, 67
Trak-In Steakhouse 59, 65, 68, 80
Trakenseen Hotel 13, 49, 51, 53, 54, 56, 58, 60, 72, 75, 101, 104, 119, 137
trolley railroad bridge 67
Tucker's riding stables 141

V

Vermont Marble Company 130, 131
Vermont Slate Belt Railway 68
Vermont State Park Beach 149
Victorian dance pavilion 63

W

Walker, Richard H. 49
Wallace Ledge 101, 147, 152
Walla Walla Country Club 145
Warren, Frederick and Rose 43, 44, 47
Webb, Charlie and Mattie 23, 26
West Castleton 19, 28
Westcott, Coulman 142
Weston Players 139
Wil-Sonia 148
Wilson, Earl 148
Woollcott, Alexander 34
Wyatt, William 93

Z

zoo
Neshobe Beach 142